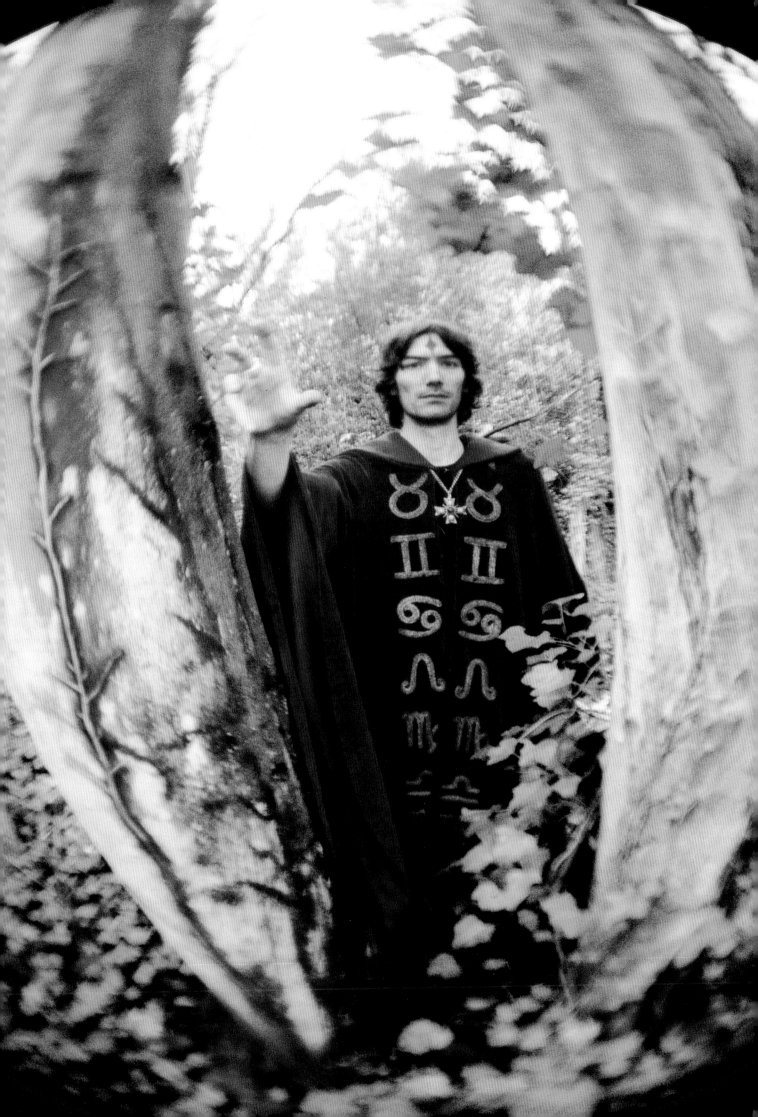

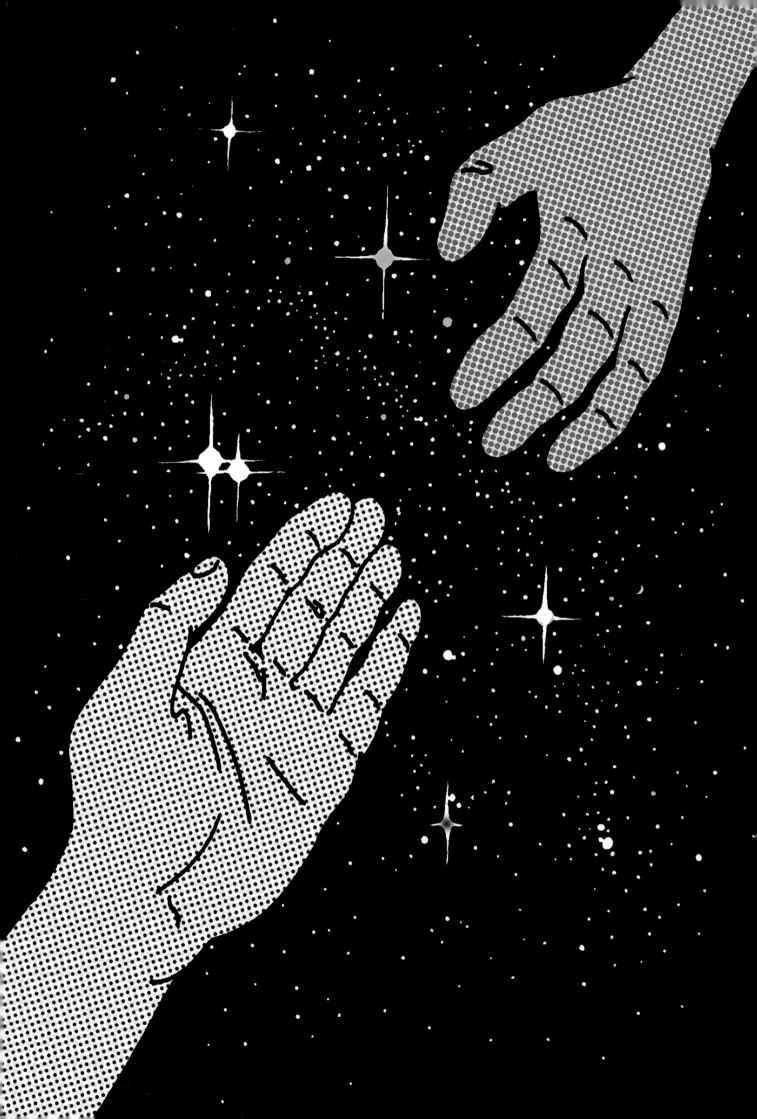

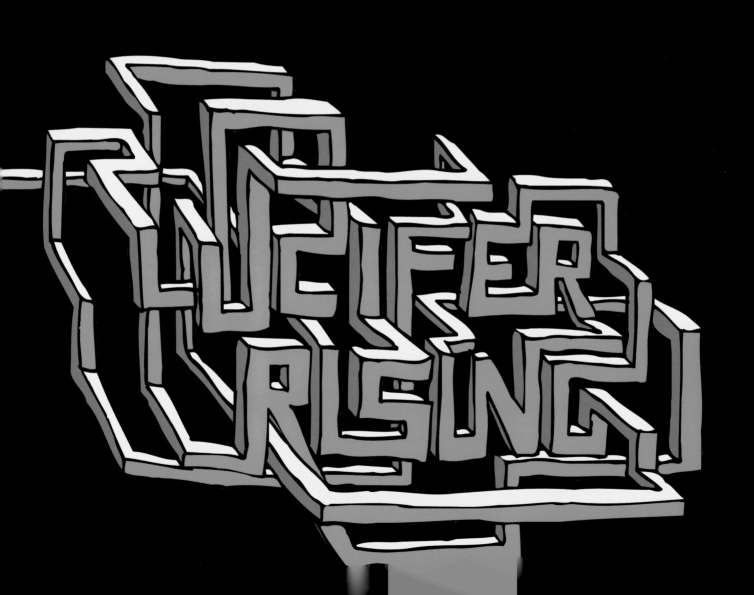

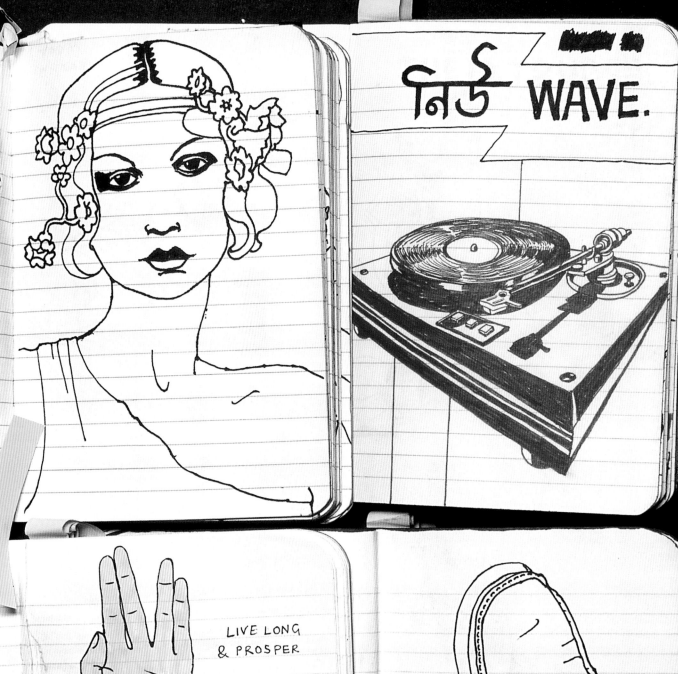

নিউ WAVE.

LIVE LONG
& PROSPER

LIVE, LONG HAIR
& PROSPER

I LOVE COMING BACK FROM A
TRIP & FINDING SAND IN MY SHOE.

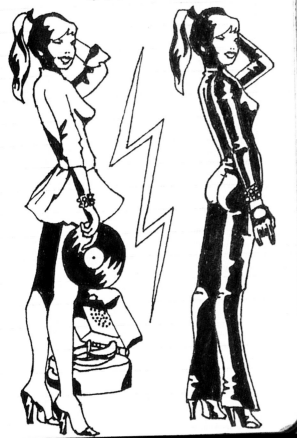

Slip on the BLACK VINYL

ADVANCED D&D™

MONSTER MANUAL

AERIAL SERVANT TO ZOMBIE

TSR

SHAG

THE MASTER ONBOARD THE DREAM MACHINE.

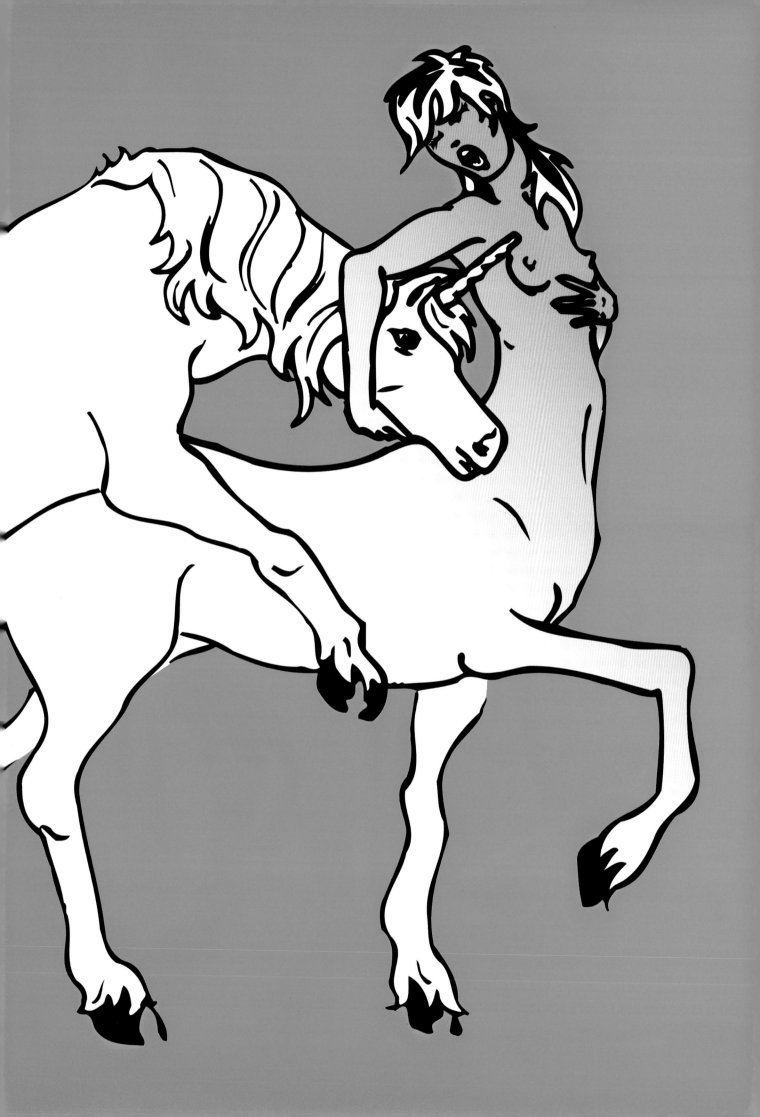

Robot

Kid

WICKER MAN

VOL 4

OZZY OSBOURNE

PARANOID

Garbage Pail Kids

WHOLE PEANUT BUTTER

340g e

Island of the Moon HONEY

NET WT. 12 OZ

HIS HOLINESS THE DALAI LAMA

the Power

& the Glory

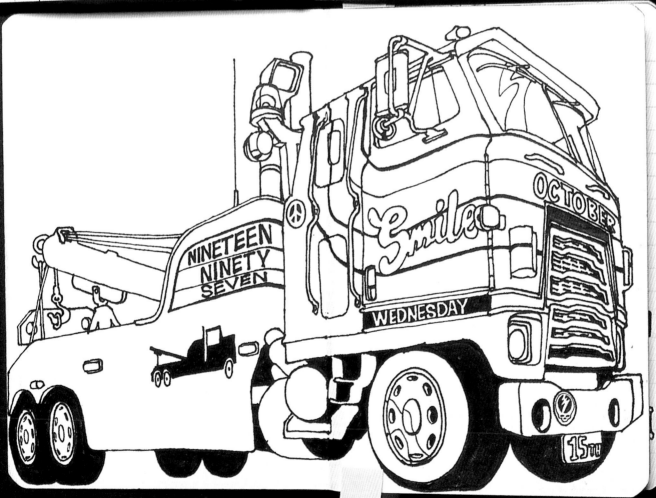

NINETEEN NINETY SEVEN

Smile

OCTOBER

WEDNESDAY

15TH

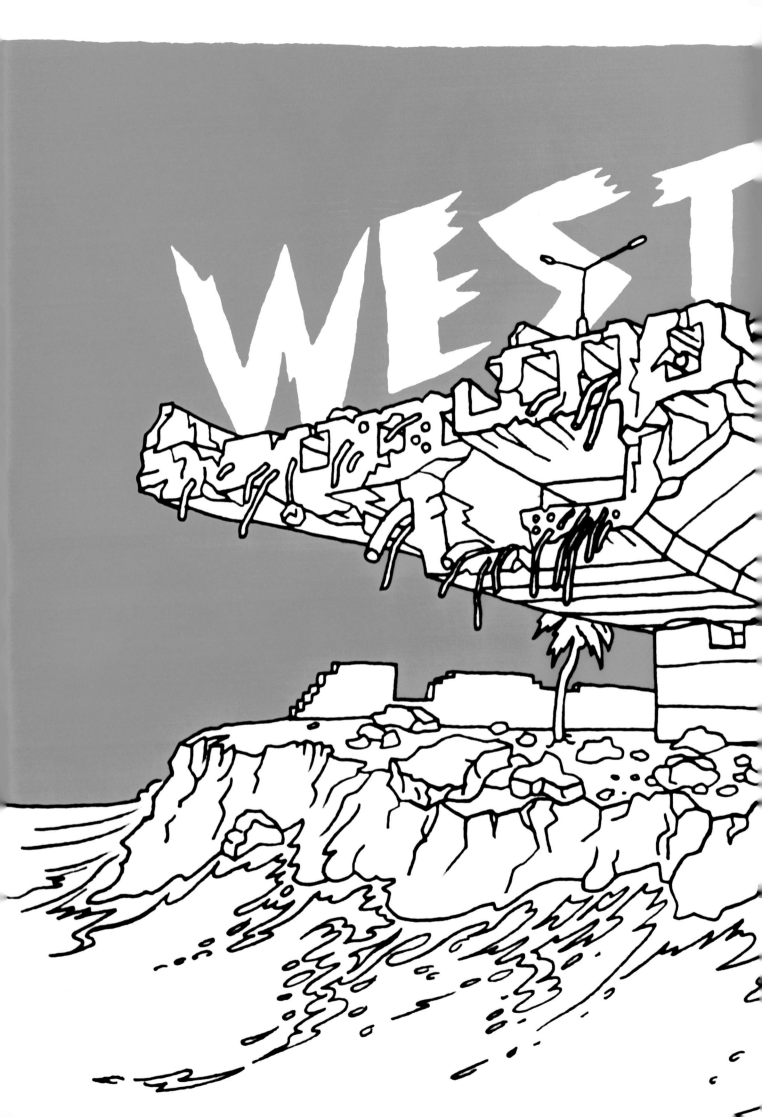

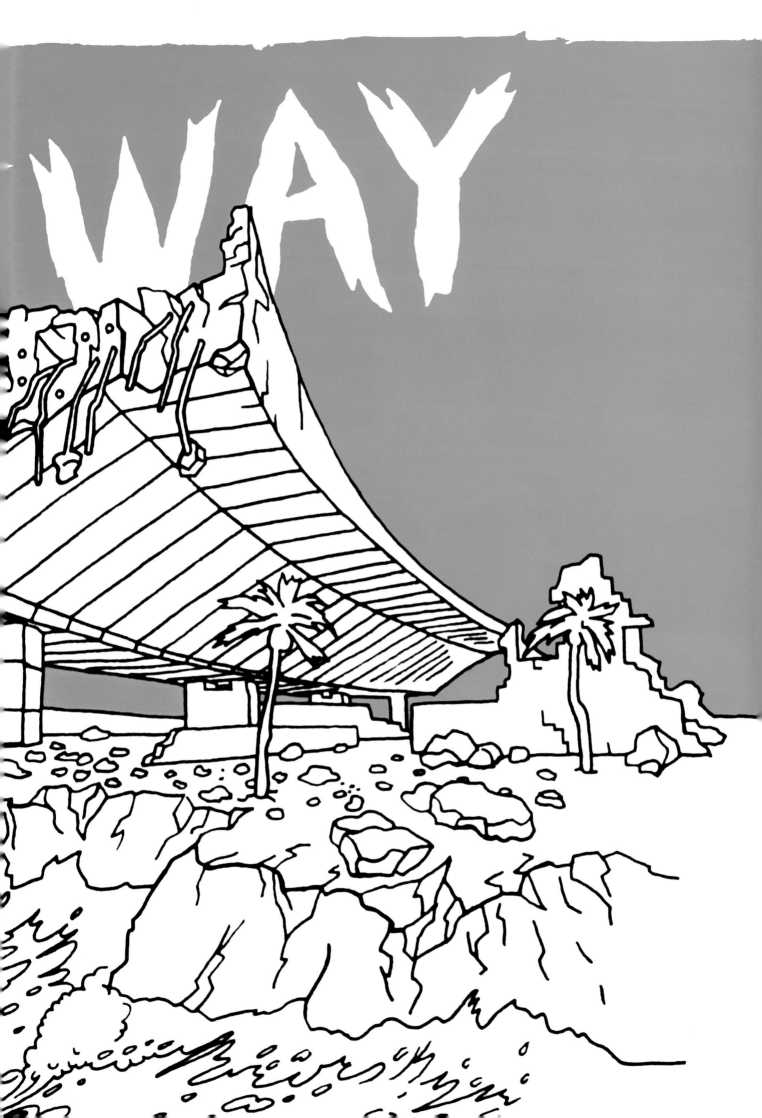

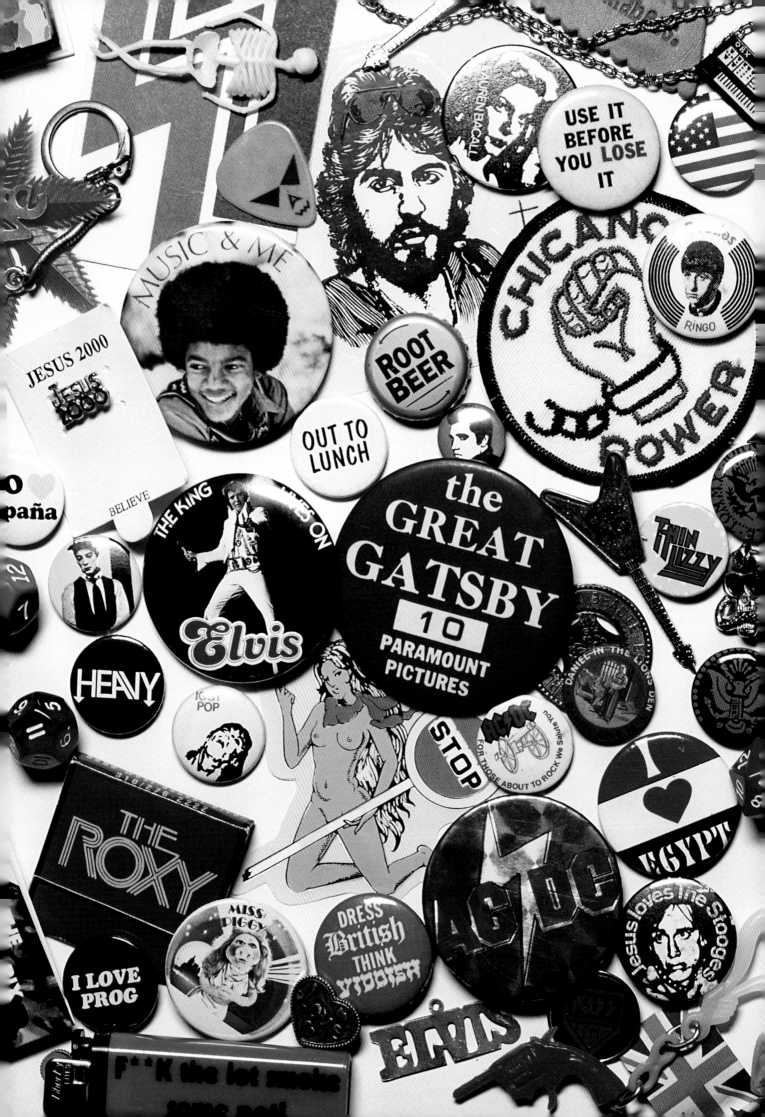

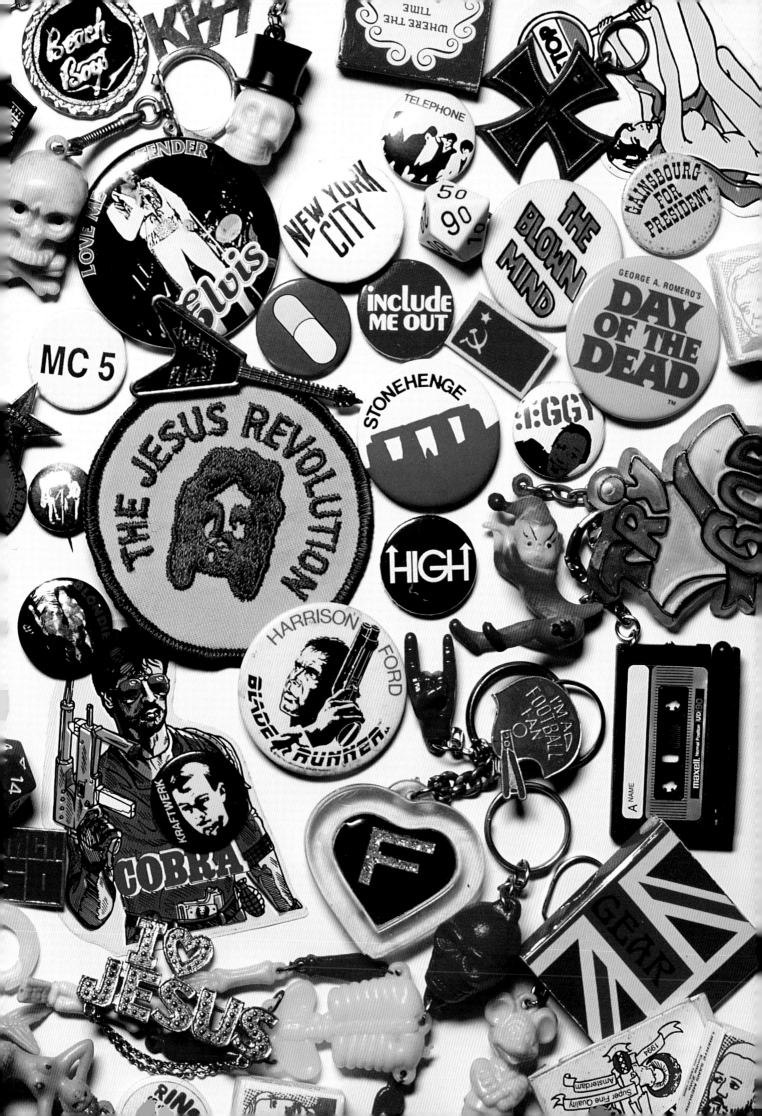

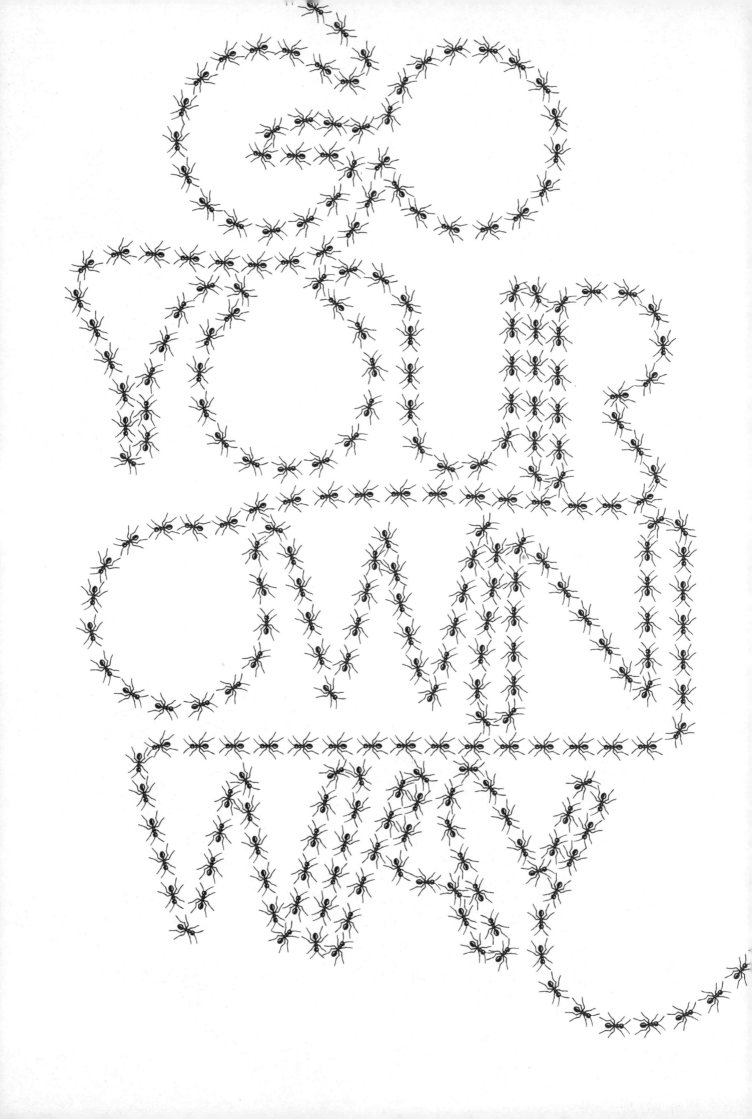

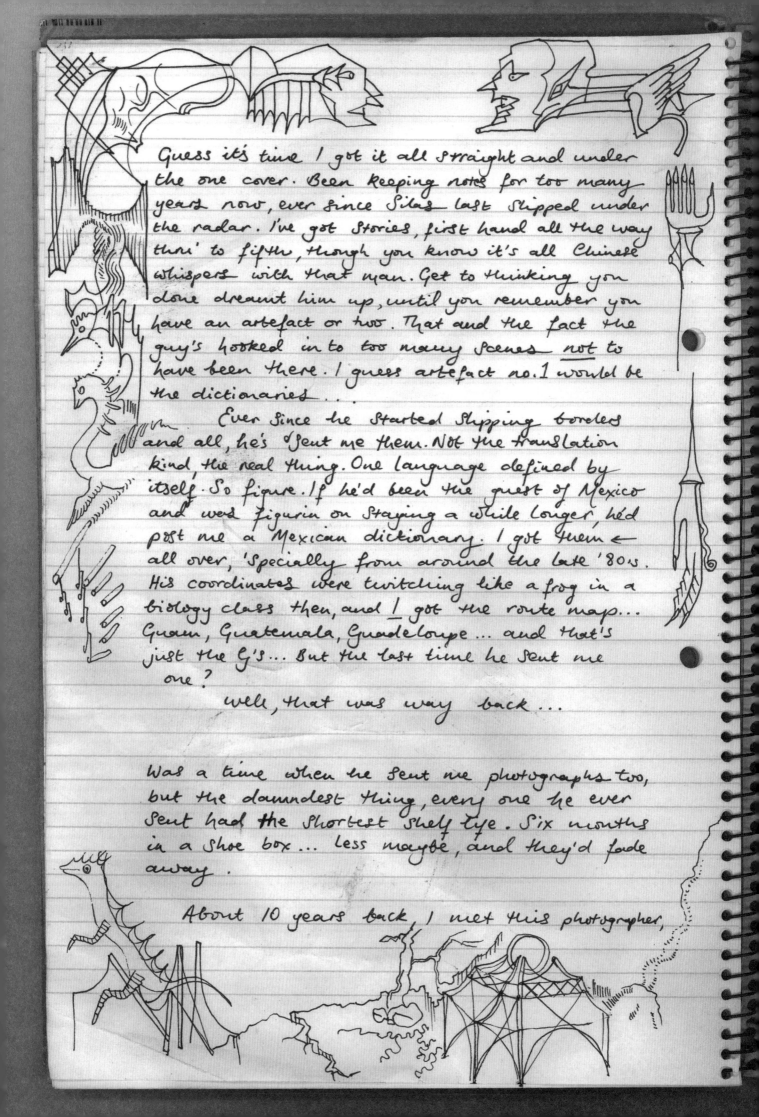

Guess it's time I got it all straight and under the one cover. Been keeping notes for too many years now, ever since Silas last slipped under the radar. I've got stories, first hand all the way thru' to fifth, though you know it's all Chinese whispers with that man. Get to thinking you done dreamt him up, until you remember you have an artefact or two. That and the fact the guy's hooked in to too many scenes <u>not</u> to have been there. I guess artefact no.1 would be the dictionaries...

Ever since he started skipping borders and all, he's sent me them. Not the translation kind, the real thing. One language defined by itself. So figure. If he'd been the guest of Mexico and was figurin on staying a while longer, he'd post me a Mexican dictionary. I got them all over, 'specially from around the late '80's. His coordinates were twitching like a frog in a biology class then, and I got the route map... Guam, Guatemala, Guadeloupe... and that's just the G's... But the last time he sent me one?

well, that was way back...

Was a time when he sent me photographs too, but the damndest thing, every one he ever sent had the shortest shelf life. Six months in a shoe box... less maybe, and they'd fade away.

About 10 years back, I met this photographer,

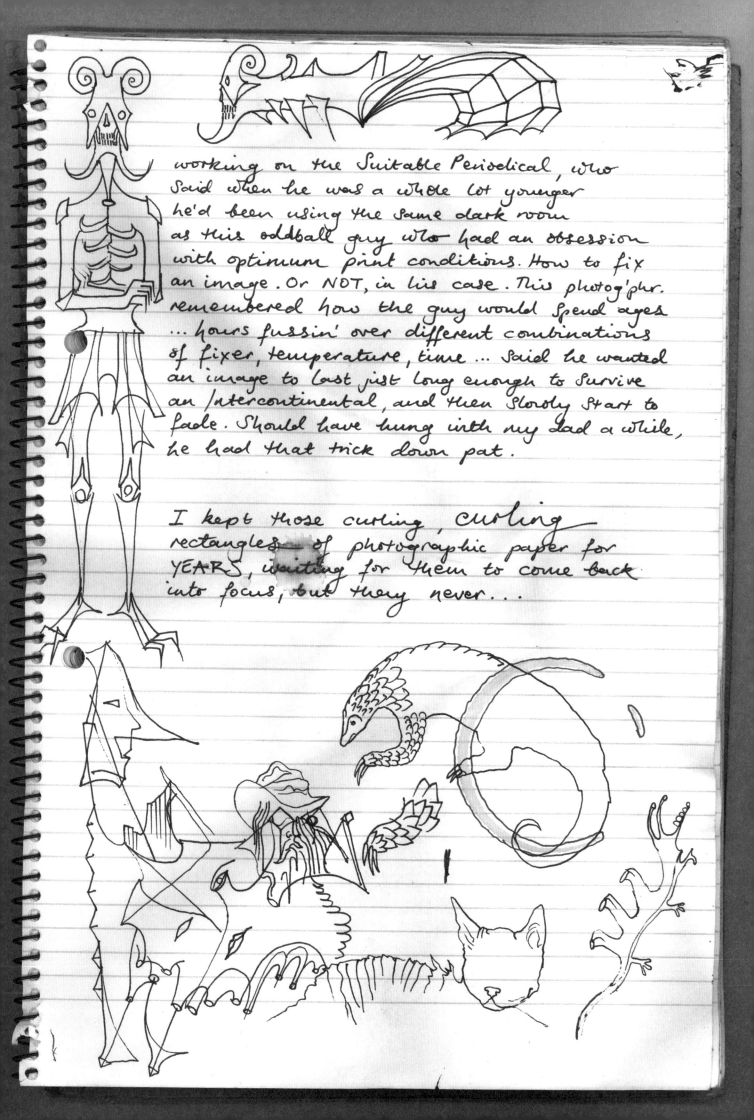

working on the Suitable Periodical, who
said when he was a whole lot younger
he'd been using the same dark room
as this oddball guy who had an obsession
with optimum print conditions. How to fix
an image. Or NOT, in his case. This photog'phr.
remembered how the guy would spend ages
... hours fussin' over different combinations
of fixer, temperature, time ... Said he wanted
an image to last just long enough to survive
an intercontinental, and then slowly start to
fade. Should have hung with my Dad a while,
he had that trick down pat.

I kept those curling, curling
rectangles of photographic paper for
YEARS, waiting for them to come back
into focus, but they never...

Okay ... So what do I know of him? Like I say, most of what I've got, I've got borrowed: second hand. But I also have one or two stories of my own. Not to mention my Ma's. My ma ... Man she was something at 21. Wilful and wealthy, she got shuffled off to relatives in Buffalo in '64, by other more immediate relatives who preferred to do without the kind of profile she was giving the family name.

And so it was that she was gunning Uncle Vernon's Ford Mustang up Route 84 that late afternoon in April, when she first saw Silas's snake-hipped and dusty

hitch hiker

on the roadside.

Guess it was one of those you-got-it-I-want-it kinda moments, cos she hauled the car up a verge and right over, till she was pointing the same way as his thumb.
He couldn't have been more'n about 15 years old (the jury's still out on the year of his birth).
Story goes that within about 15 mins. of being in that car, he'd sweet-southern-drawled her into hitting the Kesey ranch at La Honda with him. He'd been trying to get there for days.

Things between them went on-off,
on-off, from then on in for around a
decade, just like lights on a fairground.
She probably wasn't his first lady
and she sure as hell wasn't ever gonna
be his last, but they spent
some times up in those
redwoods, with the whole Prank
thing freaking around them, before she
stuffed an address in his button hole &
hauled Uncle Vernon's Mustang back to Buffalo
before she and it got any more paint
on their fenders.

Like I say, it went on-off, on-off for a while.
But then, clear out the blue, when my
mum had been back in London a good
while, near enough having forgotten Silas
existed, she got the call. High & hyper,
his story had been all over with this
name and that venue, and how he had
just finished a job here, when it had
suddenly hit him, clear outta
 nowhere
that they had never been on a 1st
date.
A date? She had queried. Like he'd
proposed something out of a different

different century. Trying to square in her mind the mores of courtship with the skinny-arsed kid she'd sipped Koolaid with and fucked in the wild and dayglo painted woods, back of Kesey's ranch.

A date?

Sure thing, he'd said.

But what a date... and this is kinda where I come in, in a reindeer-pissy hallucinogenic-hazey kinda way...

What was Dad's idea of a first date? Well... that would be to drag a girl off to the tundra to get wrecked. All he told her was to grab her ankle length sheepskin and one of her passports (just the 'one' mind, so you can see he was already of the opinion that multiple i'd's were de rigueur). I don't remember the exact route she told me, but I seem to recall it involved a coupla heavy flights and change-overs in the North. Either way they finally touched down on a tiny airstrip on the edge of the wilderness. They were the only ones there, until an acquaintance of his dropped out of the sky. Literally. Like he was

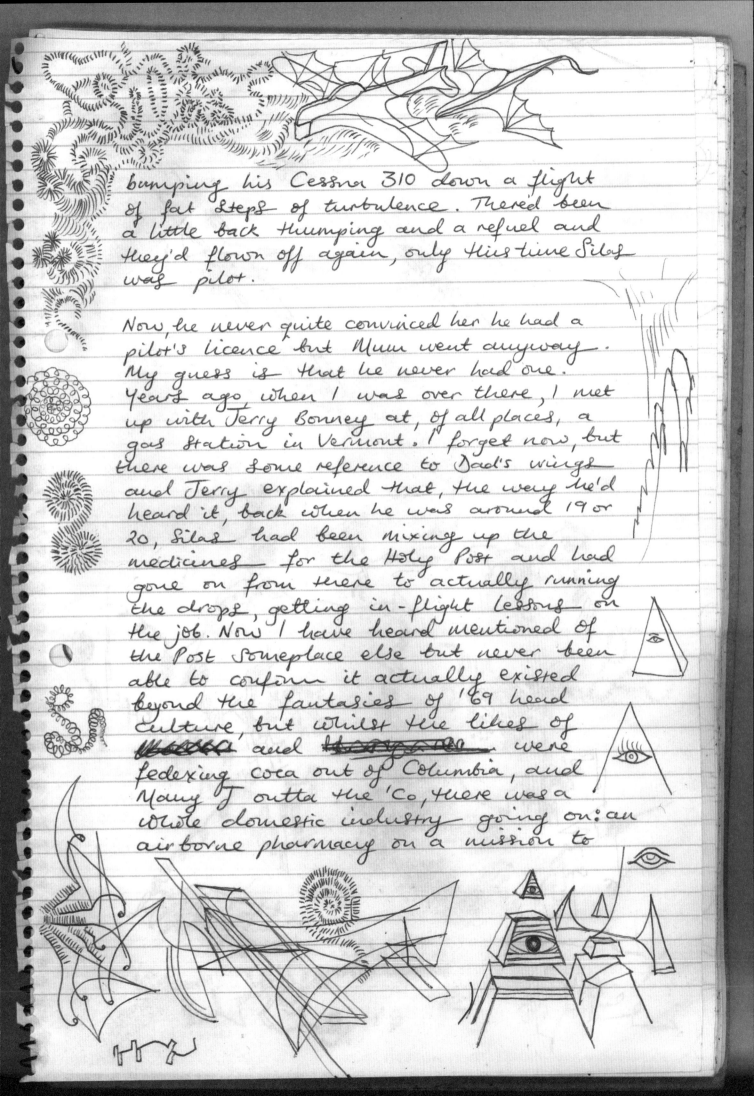

bumping his Cessna 310 down a flight of fat steps of turbulence. There'd been a little back thumping and a refuel and they'd flown off again, only this time Silas was pilot.

Now, he never quite convinced her he had a pilot's licence but Mum went anyway. My guess is that he never had one. Years ago when I was over there, I met up with Jerry Bonney at, of all places, a gas station in Vermont. I forget now, but there was some reference to Dad's wings and Jerry explained that, the way he'd heard it, back when he was around 19 or 20, Silas had been mixing up the medicines for the Holy Post and had gone on from there to actually running the drops, getting in-flight lessons on the job. Now I have heard mentioned of the Post someplace else but never been able to confirm it actually existed beyond the fantasies of '69 head culture, but whilst the likes of ~~[illegible]~~ and ~~[illegible]~~ were fedexing coca out of Columbia, and Mary J outta the 'Co, there was a whole domestic industry going on: an airborne pharmacy on a mission to

... provide the great and good with sacraments of a psychedelic nature. Anyway, he could fly, that was for sure. Though when they ended up north of the snow line knocking on the door of a derelict Shaman's, Mum decided he hadn't a clue about navigation.

Some date. She had observed.

Trust me. He had assured her.

He had heard, and God knows he had all the right sources, that the best way to ingest fly agaric was to drink the piss, hot off a reindeer that'd been grazing on them.

And, seemed it was the season... and so, I was conceived, in an endless night, in a deer skin tent, with reindeer piss rocking the foundations of my parents' worlds, whilst tripping reindeer staggered outside on the tundra. Beats me what I must have twitching in my DNA, they must've tweaked more'n'a few chromosomes that night.

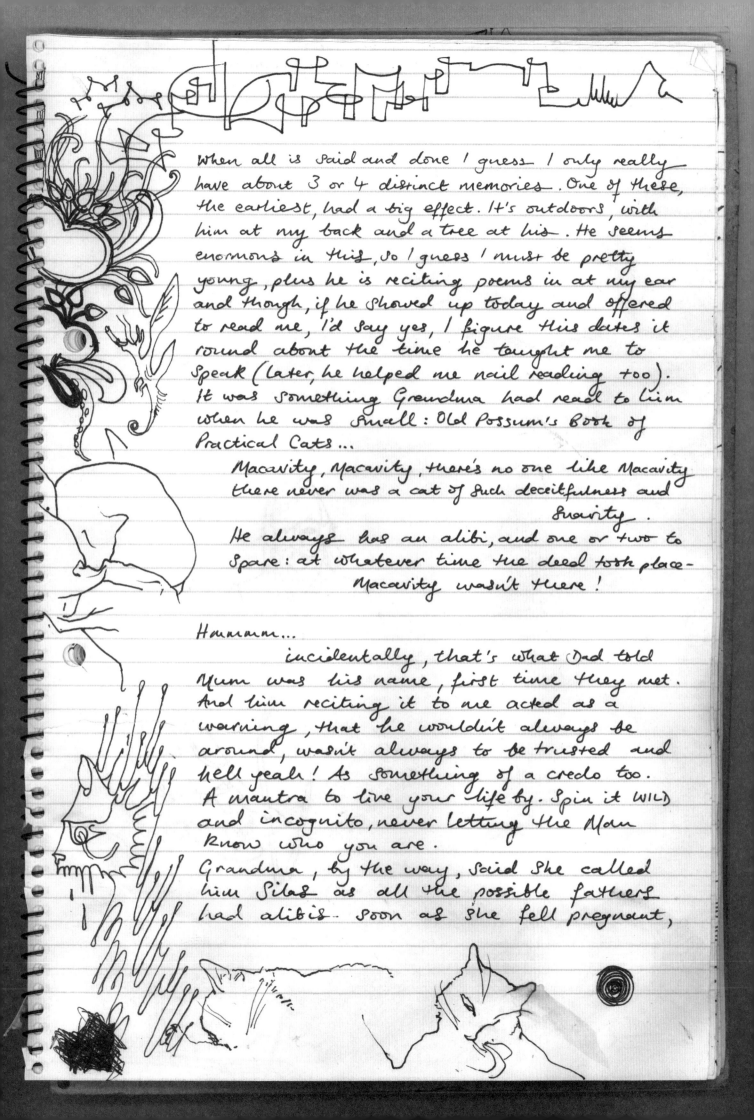

When all is said and done I guess I only really have about 3 or 4 distinct memories. One of these, the earliest, had a big effect. It's outdoors, with him at my back and a tree at his. He seems enormous in this, so I guess I must be pretty young, plus he is reciting poems in at my ear and though, if he showed up today and offered to read me, I'd say yes, I figure this dates it round about the time he taught me to speak (later, he helped me nail reading too). It was something Grandma had read to him when he was small: Old Possum's Book of Practical Cats...

Macavity, Macavity, there's no one like Macavity
there never was a cat of such deceitfulness and
suavity.
He always has an alibi, and one or two to
spare: at whatever time the deed took place —
Macavity wasn't there!

Hmmmm...

incidentally, that's what Dad told Mum was his name, first time they met. And him reciting it to me acted as a warning, that he wouldn't always be around, wasn't always to be trusted and hell yeah! As something of a credo too. A mantra to live your life by. Spin it WILD and incognito, never letting the Man know who you are.
Grandma, by the way, said she called him Silas as all the possible fathers had alibis. Soon as she fell pregnant,

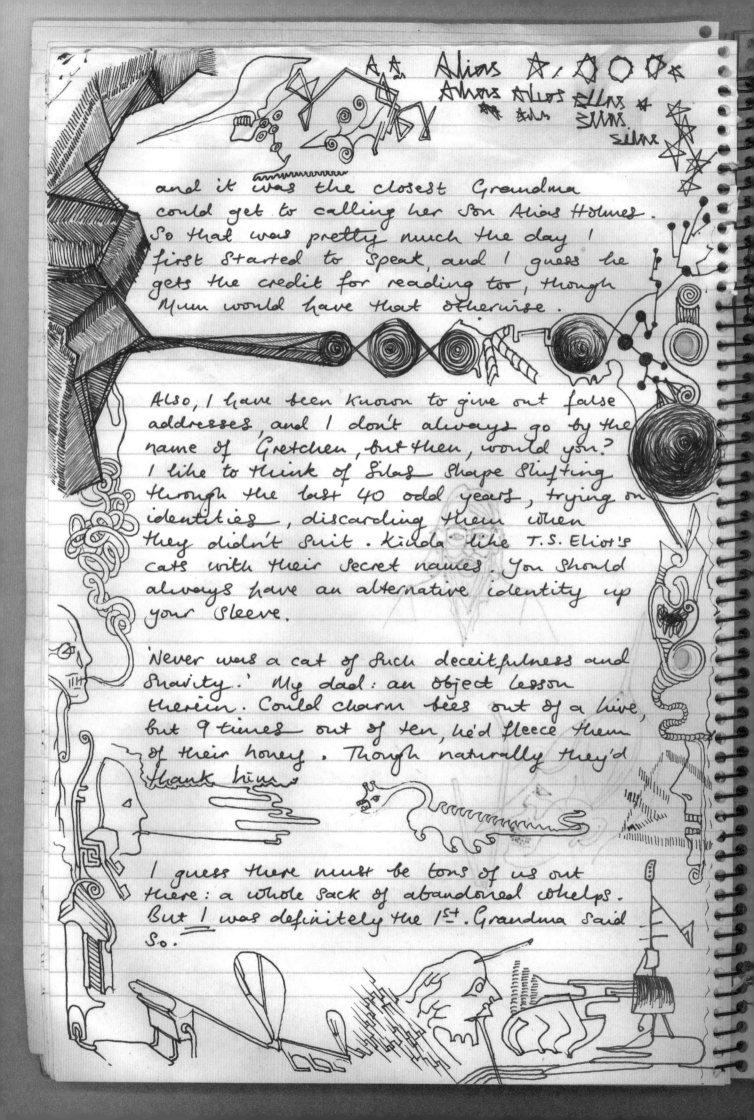

and it was the closest Grandma could get to calling her son Alias Holmes. So that was pretty much the day I first started to speak, and I guess he gets the credit for reading too, though Mum would have that otherwise.

Also, I have been known to give out false addresses, and I don't always go by the name of Gretchen, but then, would you? I like to think of Silas Shape Shifting through the last 40 odd years, trying on identities, discarding them when they didn't suit. Kinda like T.S. Eliot's cats with their secret names. You should always have an alternative identity up your sleeve.

'Never was a cat of such deceitfulness and suavity.' My dad: an object lesson therein. Could charm bees out of a hive, but 9 times out of ten, he'd fleece them of their honey. Though naturally they'd thank him.

I guess there must be tons of us out there: a whole sack of abandoned whelps. But I was definitely the 1st. Grandma said so.

weirdest thing! I was in the dentist's
just now. And got totally spooked by
a photo!

It was in one of those interiors
magazines. Some retro look at the
worst excesses of 70's design. And the
Rollergirl rug was there! I know we were
out in L.A. when I was about 4 or 5,
but all I can really remember
is being sat, on this enormous
carpet and tryin to work out the
pattern. And it's not until I looked up
and clocked the whole thing in the
entirely mirrored ceiling, that I could see
I was sat right in the lap of a giant,
golden haired, shag piled babe in peacock
hotpants and aquamarine skates.

In tiny letters, spelt out vertically
alongside the photo: reproduced,
kind permission: S. Holmes ...

Naturally I have ripped it and
brought it home to go with the others.
Man, that receptionista was snippy!
Damn, what was the magazine
called? Come to think of it, I
never clocked the date or issue
number either...

Klias
Klias Holmes
Klias Klias
Gretchen

God damn, it's been raining for days, but this bites. It's coming down in rods. I ain't never gonna sleep at this rate. Kinda reminds me of Grandma's funeral.

I wasn't so old, and wasn't tall enough to get more than a waist high perspective on it all, which meant mostly that I got a better view of the puddles, bouncing like they had a whole lot of something to say; chucking mud up the pall bearers' legs and all.

Of course Grandma only returned to Louisiana after she retired and it wasn't long after that she died. Yet, in spite of all those years away, she had one hell of a send off. They musta bussed in every last hooker she ever worked alongside, on a last rites jamboree... that and one or two of her more doting customers.
I was just a little stick in a wet dress wonderin' at all the costume and flap. Pretty much how Silas musta done when he was growing up. That man was hauled into the earth by those ladies of the night and they'll help him back out of it too.

That is if they haven't already.

God I got the shivers now. Better go get a sweater.

Best thing about that day was earwiggin' all the reminiscing. That and roamin' Grandma's, fiddling with all her things. She had this one thing: thin, hand-set pamphlet with a green cover, I remember: had some of Dad's poetry inside. Mum had one to I think, though maybe I imagined that cos' god knows where it got to. Sure as hell didn't wind up

MY way!

Story goes, he didn't want to make any capital outta all those old Beats he was 'mentored' by. (least that's what Ginsberg called it: 'mentoring'.) So he stuck one of his soon to be many pseudonyms on it. Guess he didn't want Allan and Ferlinghetti and all those others, tootin him as 'THE NEXT BIG THING'.

I remember Grandma's copy because I always thought it was a clue to who Grandpa might have been.

Got a bit sidetracked there ... where was I?
Dad's poems ... Gramma's copy ...
 reason I thought it had a clue to
Grandpa was the inscription. It was as if
she was planning on gifting it to
somebody but never. Went something
like: Charlie B (pretty sure it was a B)
your boy's got poetry and women
both, a-runnin in his blood.
 Thought you might recognise your own...

"Charlie B Charlie B" Old Auntie Patty
had nursed long and hard, when she
found me bouncing at the wake on
Grandma's bed in her nightdress &
rubies book in hand... "Yup, I
recall him. Some deadbeat poet with
a wild look in him. Always moving
from one rooming house to the next.
Had a cute enough way with him I
guess, else your Grandmother woulda
made him pay, which she never.
But... I don't know poets , I'm
afraid Hon'... just know they aint
worth a dime as tricks."

Dad, on the other hand, always

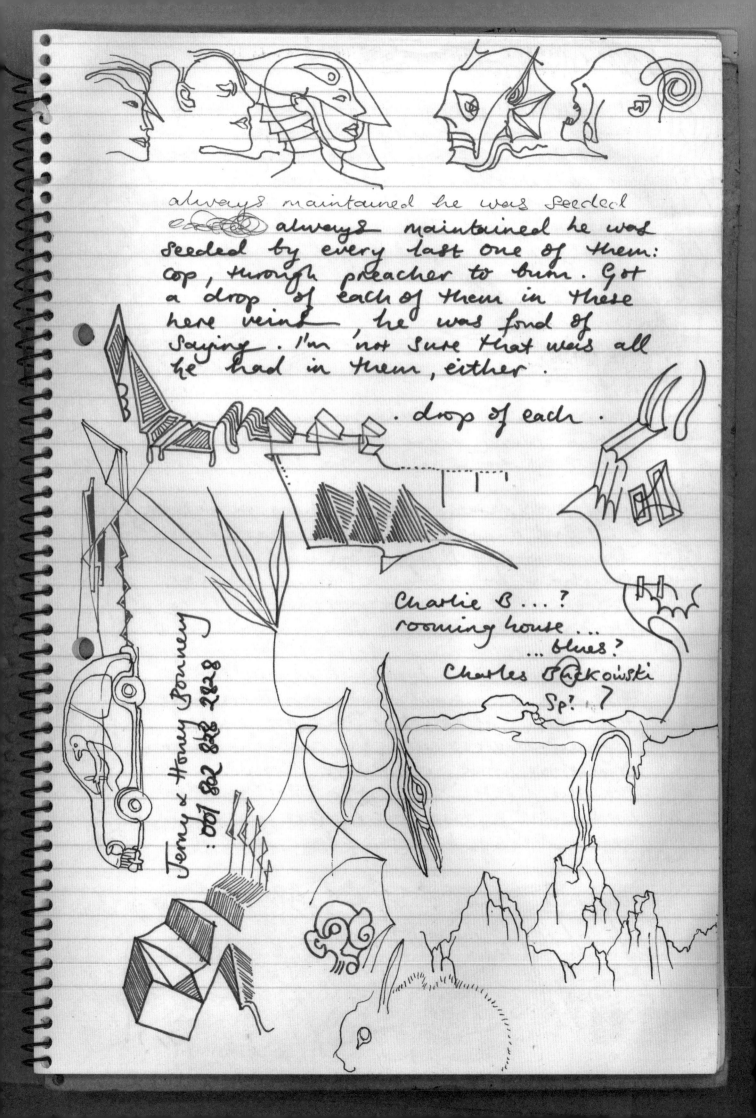

always maintained he was seeded
~~~always maintained he was
seeded by every last one of them:
cop, through preacher to bum. Got
a drop of each of them in these
here veins, he was fond of
saying. I'm not sure that was all
he had in them, either.

. drop of each .

Charlie B ...?
rooming house ...
        ... blues?
Charles Bukowski
   Sp? ?

Terry & Honey Bonney
  : 001 852 852 2828

I don't really know what I was going to write this evening. I'd been recalling a story Rube Shapiro told me about Silas, 'bout how he wound up smoking all Mark Frechette's weed on the set of Zabriskie Point and nearly got dumped (giggling like a prairie dog) out in the desert for his trouble. But, I keep getting side-tracked.

Been feeling a little paranoid lately. Not so much about where he is or whether he is, more the why's?

Why ever time there's a piece or a book (and God knows these past years have been chock full of biogs and such), somehow he always winds up as a footnote. Like that piece in Rolling Stone in '86. I mean! Shapiro said there was gonna be a whole paragraph with names and all. But, well. Business as usual I guess. There was that film of course. That got pulled. I guess there must be rushes in a can somewhere, but you know they'll never see the light. In fact, aside from Big Wednesday, the only place you could get to seeing him on film is Z.P.

I kinda squinted the one time I got all
the way through that. Last thing you need
to be seeing on celluloid is your pa writhing
about in some psych'orgy scene shot in
Death Valley.
Rube Shapiro said Silas had hooked up
with someone from an avant garde drama
group, when still at La Honda, and talk of
group sex scenes had got him volunteering
his services. Though Rube reckon
reckoned it may have been the prospect
of a whole stack of explosives going
begging that had persuaded him to
sign on as a bit part. 'Bit' being the
operative, I guess.

Personally, I go with the dynamite,
because ... Chester Levertov, who
used to hang around KPPC - FM,
also thought it was the prospect of
making his own bangs
rather than banging art chicks,
that reeled Silas in.

Incidentally, Levertov told me
once that, contrary to stories,
Holmes had nothing to do
with the Frechette bank heist...
hadn't been seen in Boston since long before
'73.

What's my sweetest memory by far? That would be when the big, beautiful-ugly guy plucked me out of Brownie camp and rode off into the sunset with me. Least that's how it plays in retrospect.

Mum always said it went something like this:

I was a pain in the arse, so she figured Brownie camp and church would fix it. Away way, clear out the blue Dad calls icing. I still can't see that shade of brown without shuddering. up and she mentions that no, he can't see me during the whatever dates my camp-fire purgatory fell on, because... well, he never got the because. Didn't get it at all.

A daughter of his, in an ₰ unarmed militia of 8 year olds, pledging allegiance to god and crown? What sort of jive was this? She was putting him on, right? No. Slams the phone down.

Things weren't great between them by this point.

First thing he did was run down to the cable cable office & telegraph me:

Rapunzel. Stop.
Don't sweat it. Stop.
White charger on way. Stop, stoppity.
Stop.

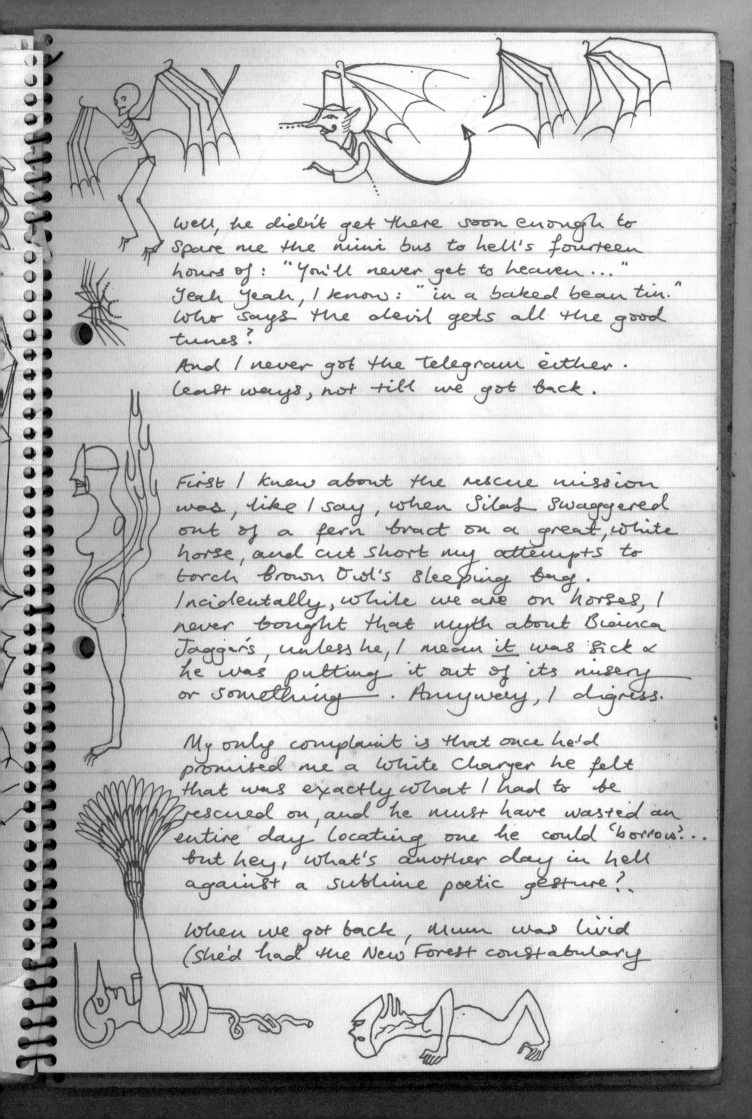

Well, he didn't get there soon enough to
spare me the mini bus to hell's fourteen
hours of: "You'll never get to heaven..."
Yeah Yeah, I know: "in a baked bean tin."
Who says the devil gets all the good
tunes?
And I never got the telegram either.
Least ways, not till we got back.

First I knew about the rescue mission
was, like I say, when Silas swaggered
out of a fern bract on a great, white
horse, and cut short my attempts to
torch Brown Owl's sleeping bag.
Incidentally, while we are on horses, I
never bought that myth about Bianca
Jagger's, unless he, I mean it was sick &
he was putting it out of its misery
or something . Anyway, I digress.

My only complaint is that once he'd
promised me a white charger he felt
that was exactly what I had to be
rescued on, and he must have wasted an
entire day locating one he could 'borrow'...
but hey, what's another day in hell
against a sublime poetic gesture?

When we got back, Mum was livid
(she'd had the New Forest constabulary

on the phone for an hour) but all he
could say was:

no daughter of mine
gets sent to military school.
"Silas," she'd sighed. "It's just the
Brownies."
"Whatever. Uniforms and anthems
aren't working for me, Baby. If Gretch
wants to play campfire & outback
I will introduce her to Jean Gonzeaux."

[Real Gone Jean: he was a french
Canadian trapper who, I hear, the
Weathermen / Weather Men used to send
wannabe recruits to, to scare 'em off.]

"Coupla weeks out at Bitterroot with
nothing but a blade and her
buckskins should teach her a trick
or two. Come on kiddo! What say
we head on back to the hinterland
with a coupla sniper rifles and
bag us a 'brown owl?'"

                    ... Come on kiddo...

Anyway, I heard years later that the
reason I never got the telegram till after-
wards, and why he never got there
in time to stop me leaving in that
mini bus, was that the message had
been intercepted by the DEA and

they had turned him over at Customs.
Seems they were damn sure 'white
charger' was code for something more
on the pharmaceutical side. Maybe the
Holy Post hadn't been as hush-hush
as they'd hoped. Seems to me they
must have had a reason to be checking
his messages in the 1st place. People in
places, keeping tabs.

Anyway, after that, I used to imagine
him, working his way round the
globe, rescuing my unknown
siblings from a fate
worse than conformity.                Giving
them all the identity          spiel,
'bout how they got your         name,
they got your number, and then,
your number's up, yadda yadda...
keep it loose. Words lost on the pre-
teens, who don't have their own
passport, never mind more than
one.

Spent the first fortnight of
boarding school with the smug
look of the:
   'Those-Who-Are-About-To-Be-Rescued'

but the bastard never showed.

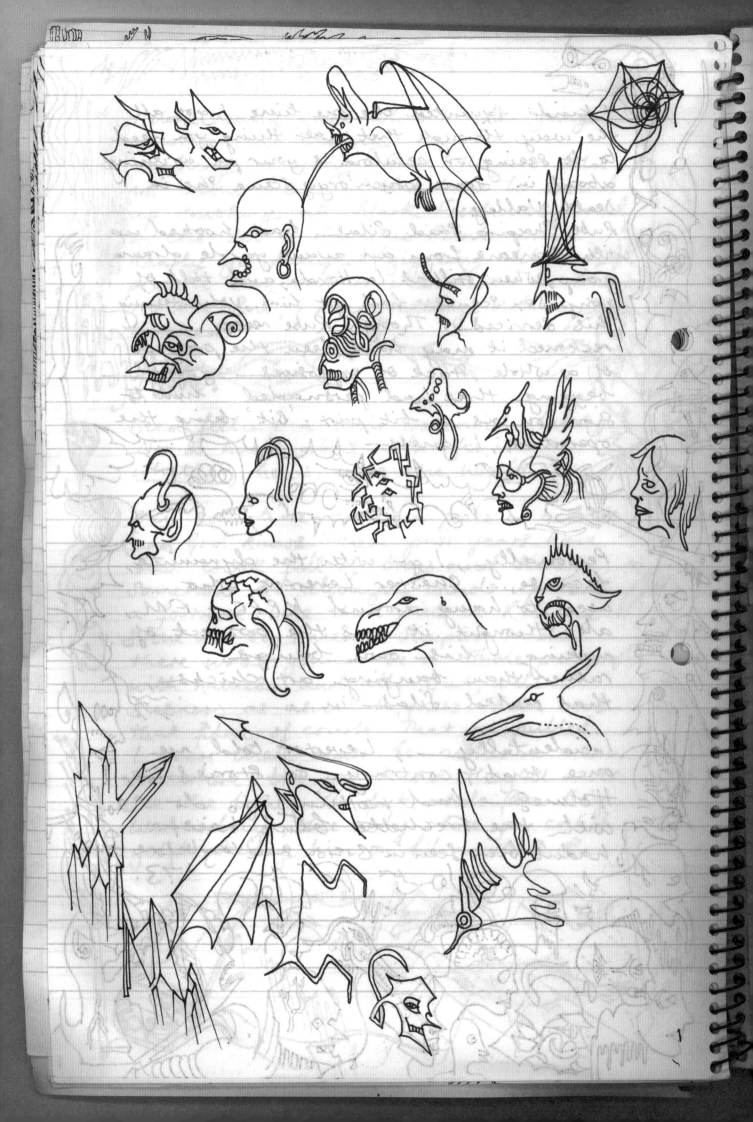

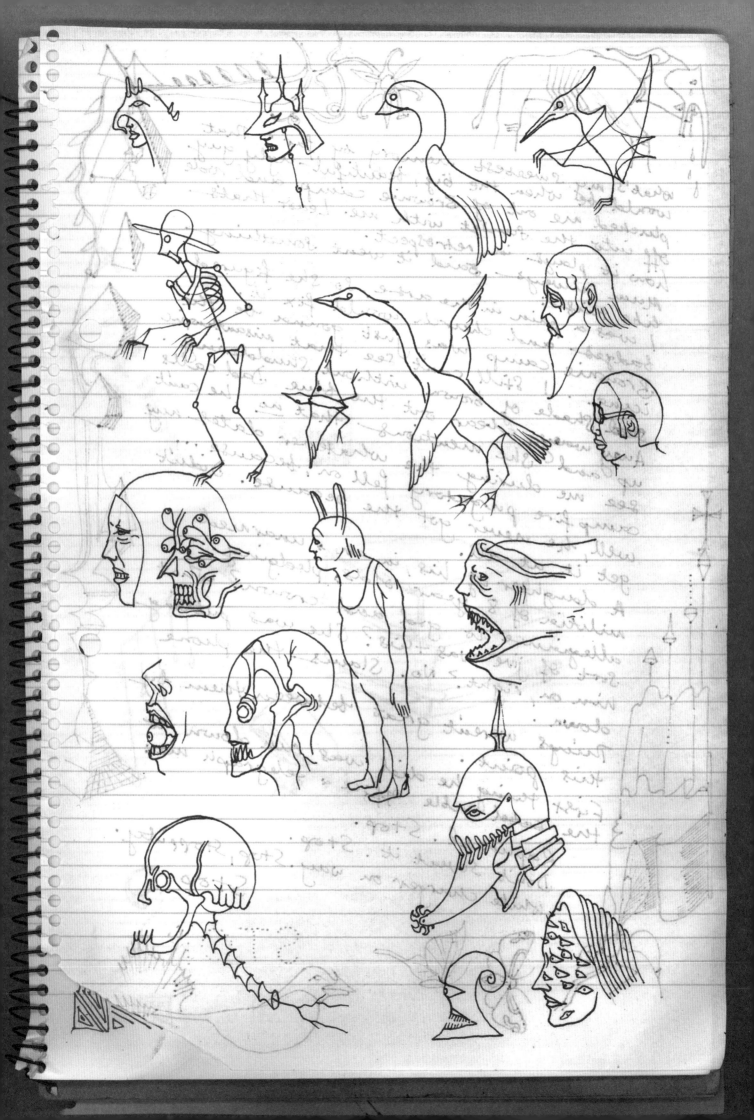

I did not spend as much time with my father as I would have liked to. But the time we had together I cherish.

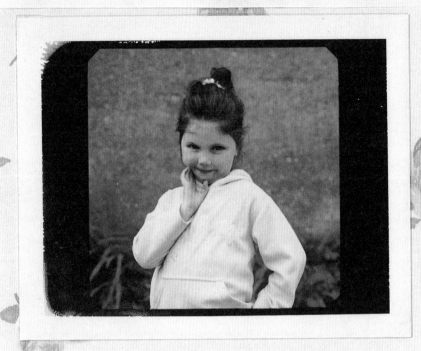

We had
had gon
across m

We (me and my Dad) both love ice cream.

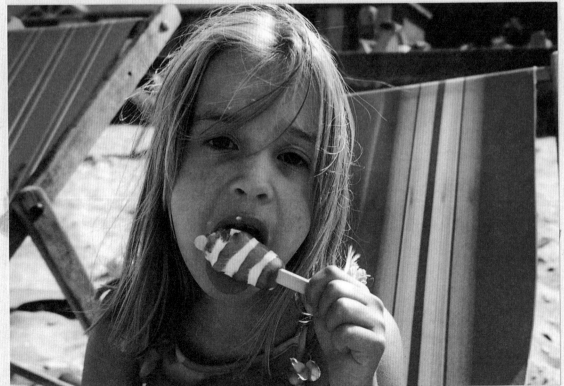

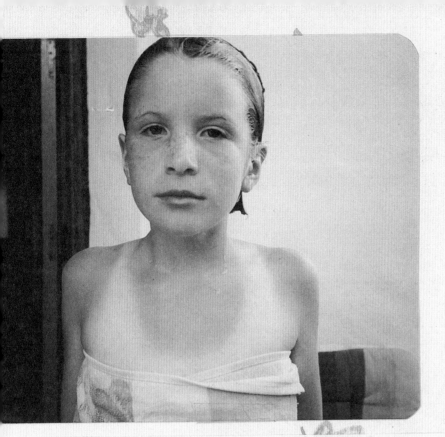

...ust been swimming in the pool until the sun behind the trees. I had a line of freckles nose- just like dad did.

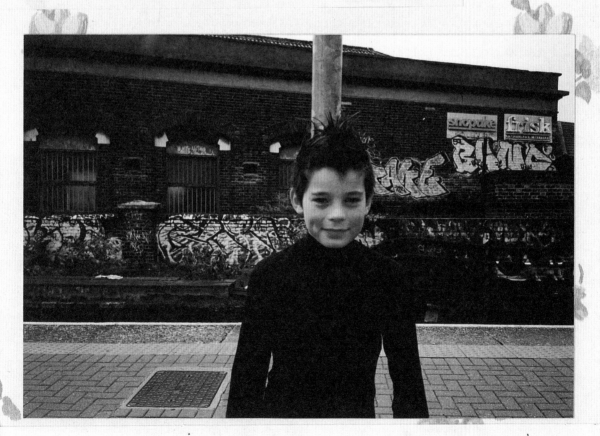

Dad once took me away with him when Mum was sick. He loved travelling. We spent a lot of time together then, and it was the closest I ever felt to him.

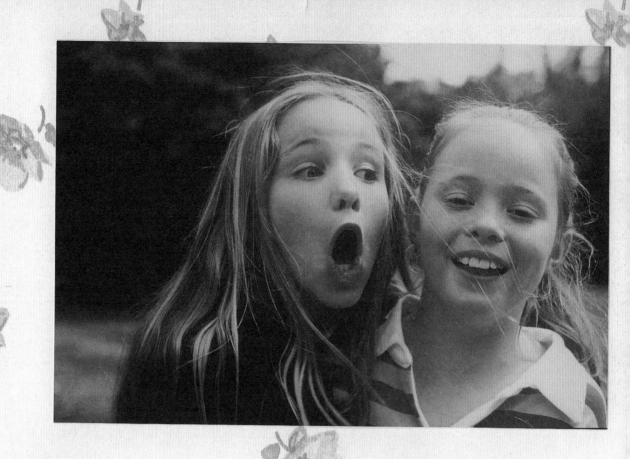

Dad used to love playing games. He'd get all the kids in the neighbourhood to join in. It was brilliant. This time there were about 20 of us playing. We'd go on until it got dark and everyone's Mum's had called them in for their tea.

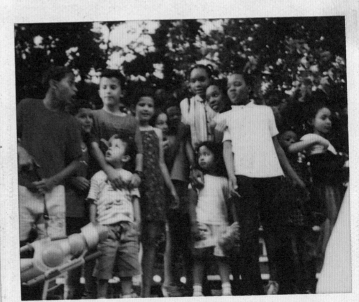

We are twins (non identical) apparently Maddie looks just like daddy when he was little.

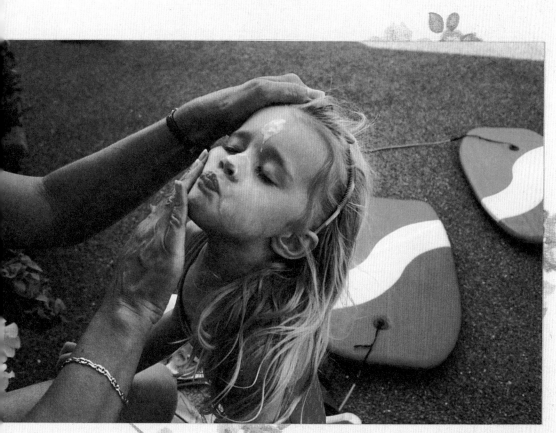

I used to love going to the beach with my Dad. He taught me to surf and he was the best surfer! Once we went to the beach and the waves were really huge and I fell off my boogie board. I thought I was going to drown but he scooped me up out of danger. Like Superman.

do you know where he is?

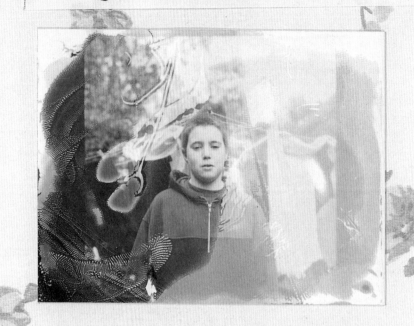

Dad bought me a sega mega-drive. I play is
and it reminds me of him.

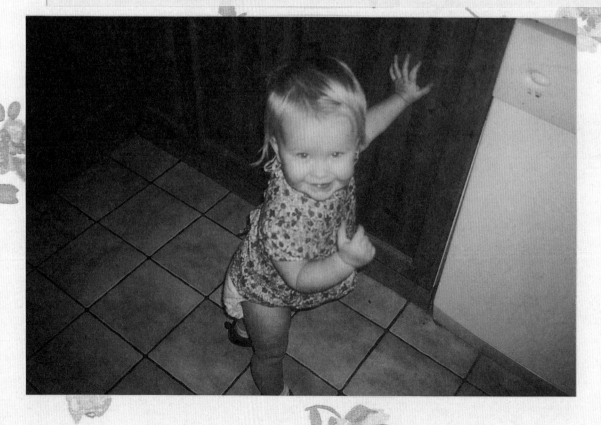

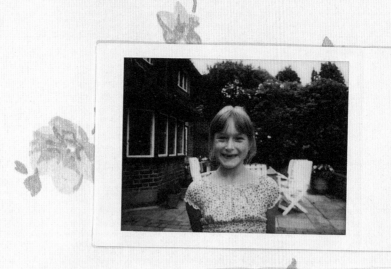

Dad took this picture of me when I'd lost all my front teeth, he thought I looked very funny. Its his favourite photo of me.

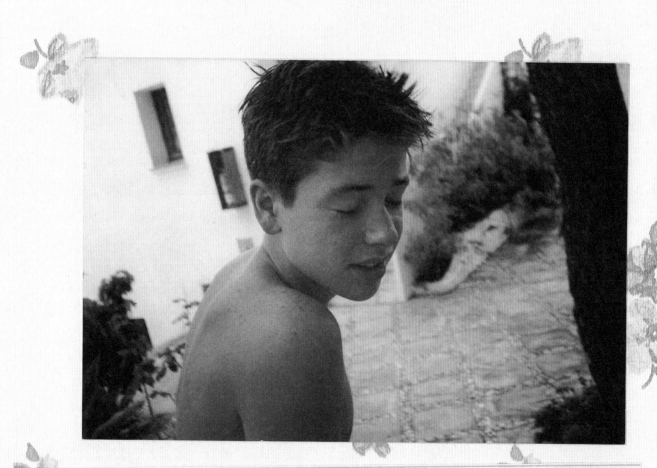

I loved skating then, and Dad used to come and watch me. I'm still skating. It would be cool if he turned up to see me now.

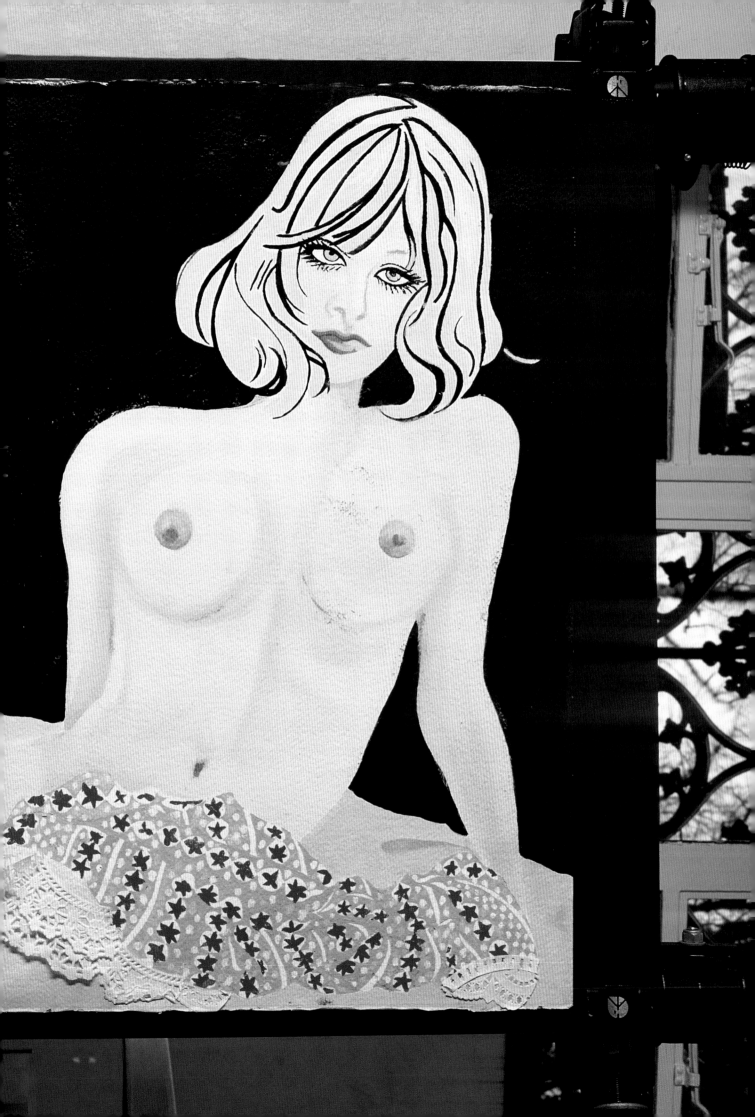

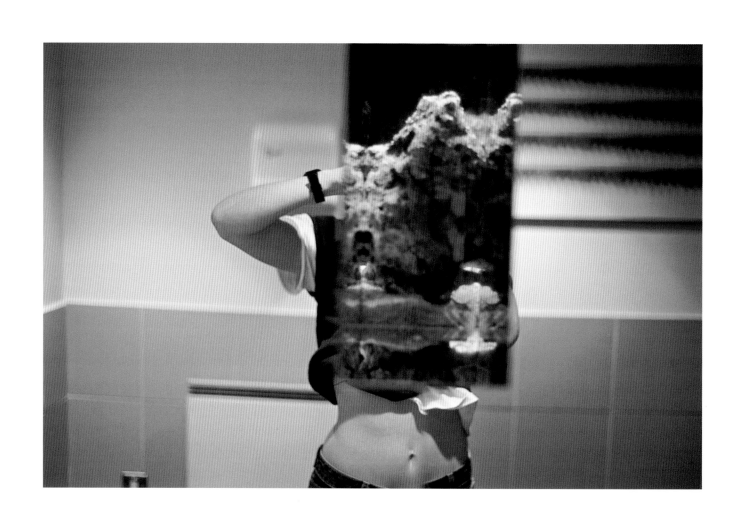

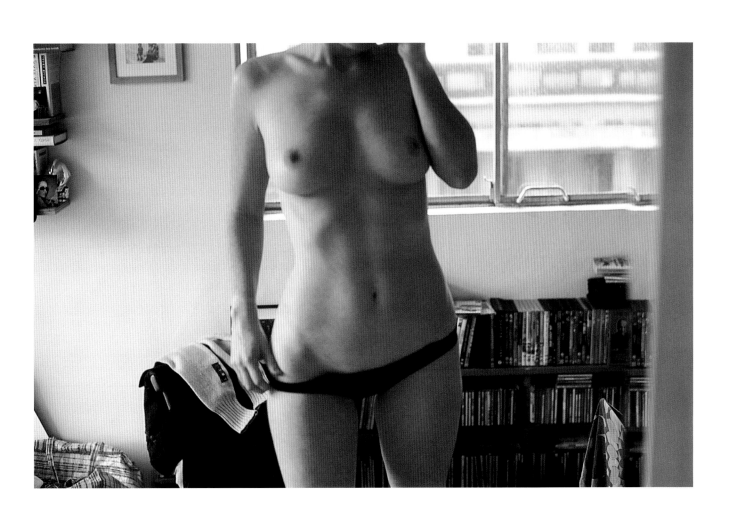

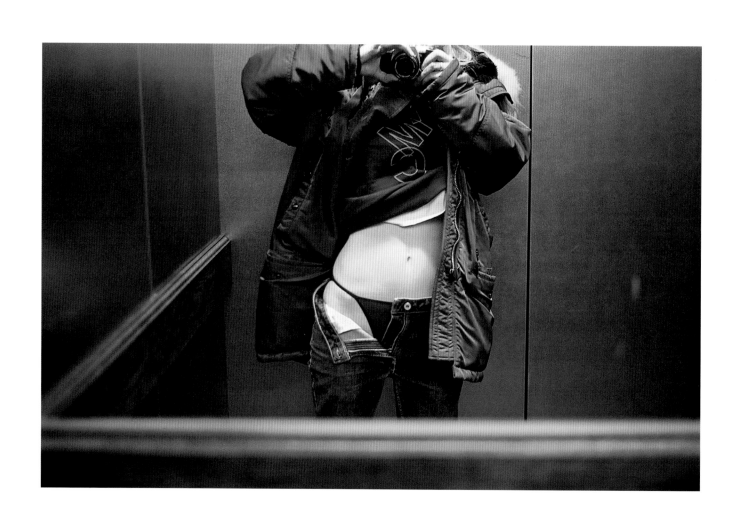

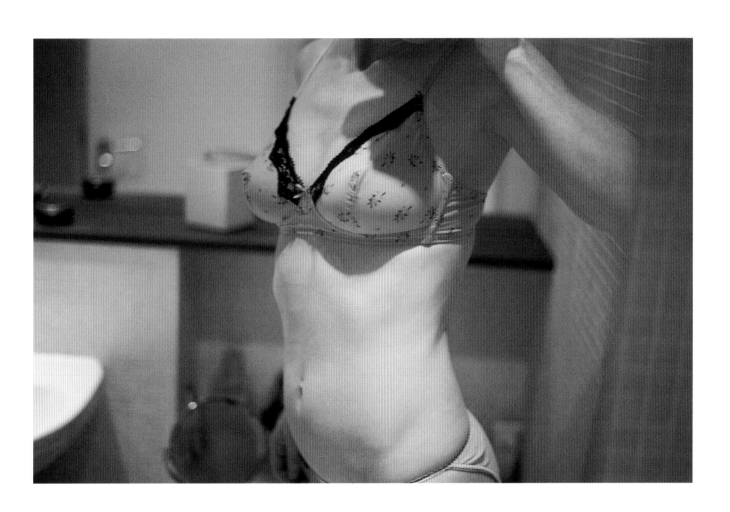

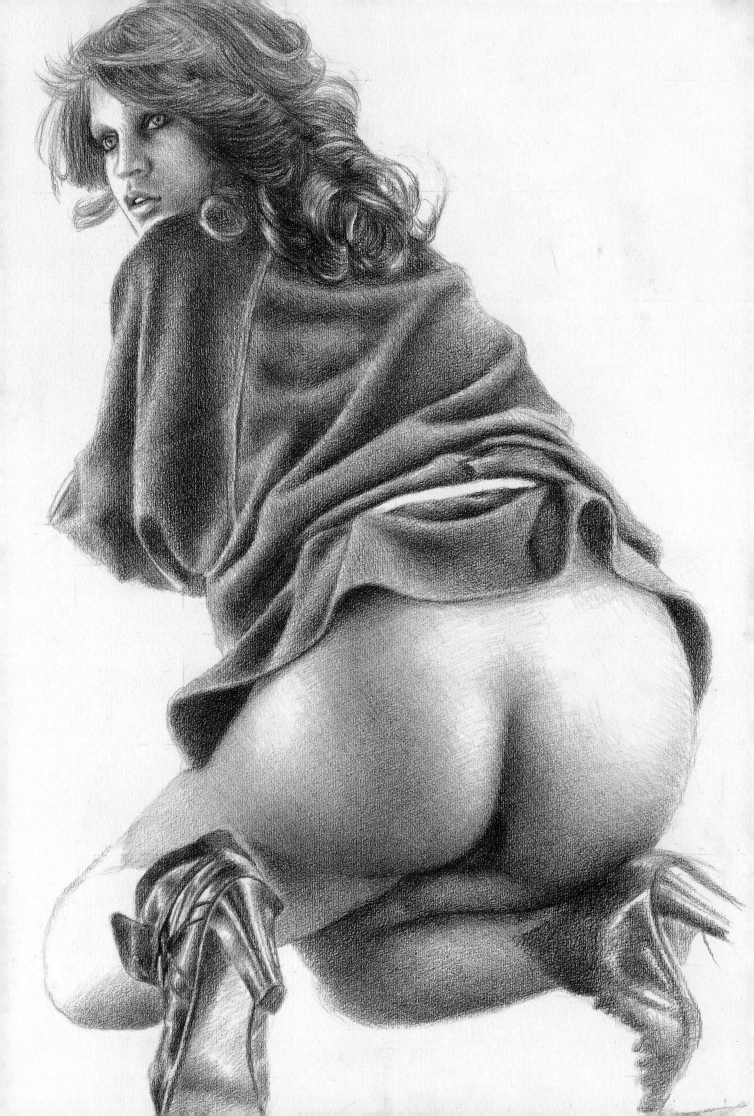

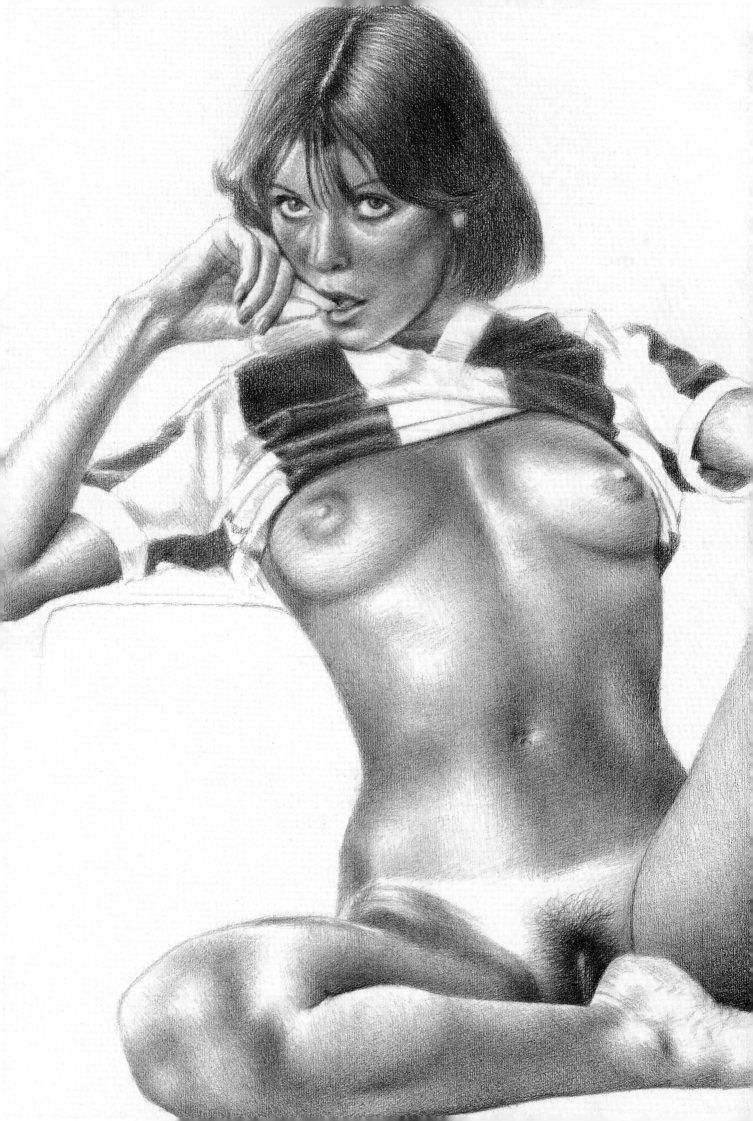

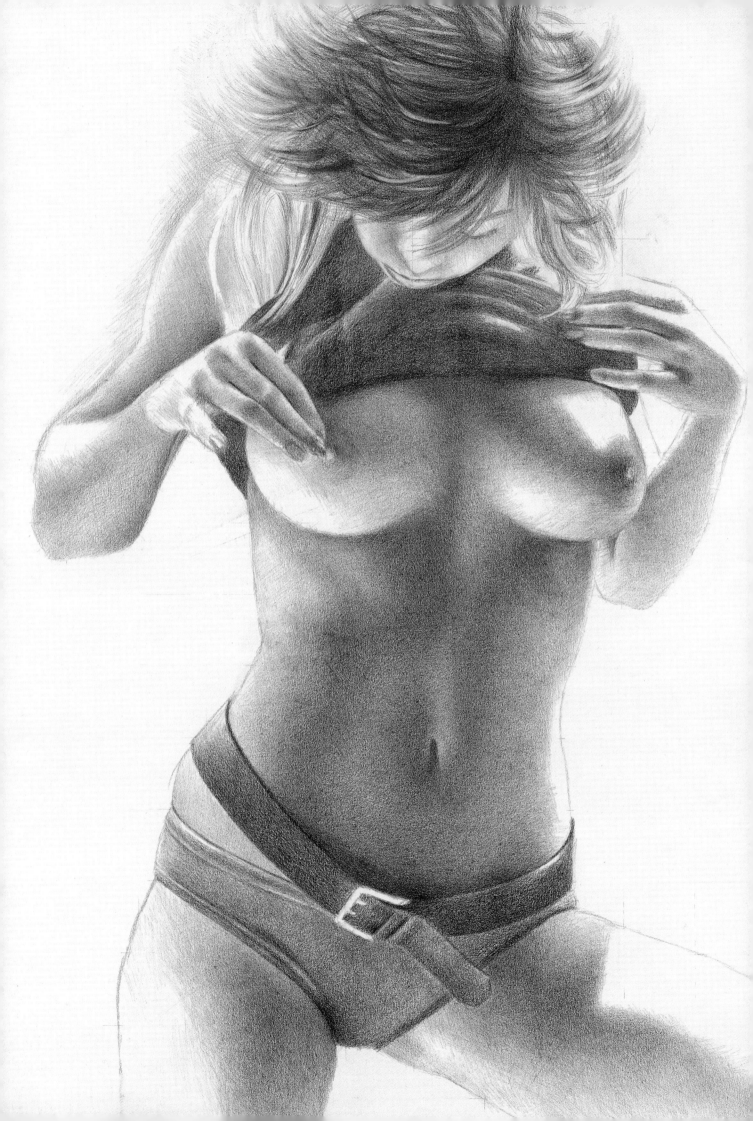

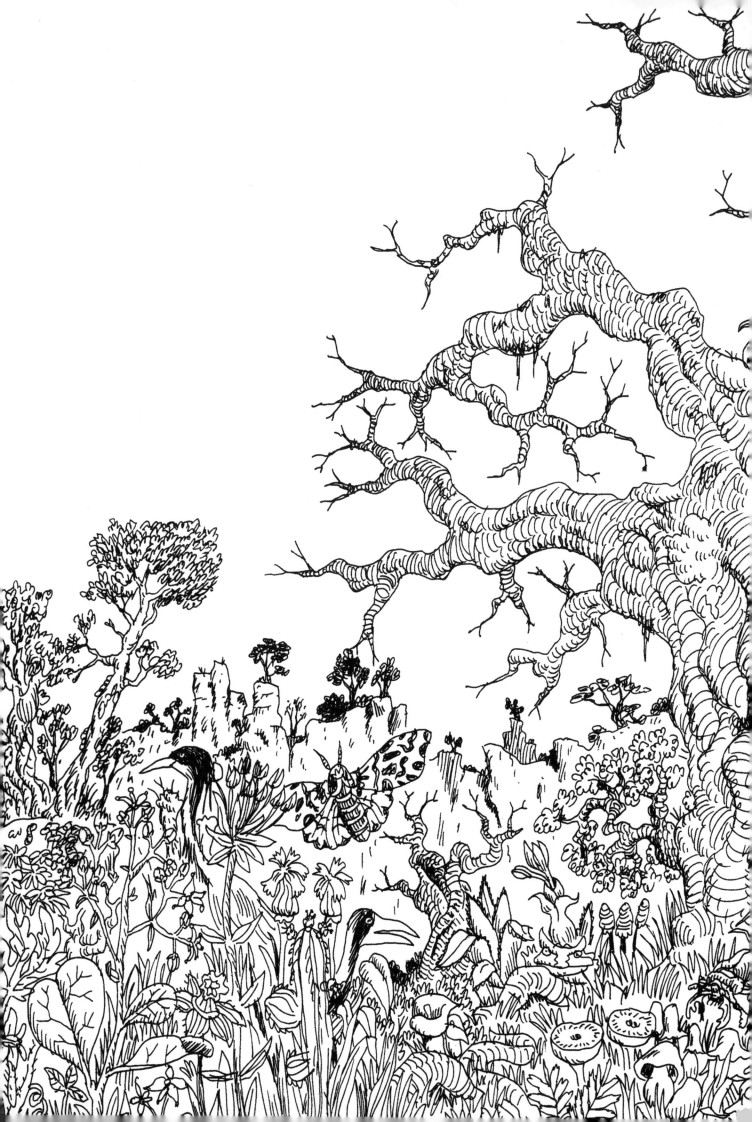

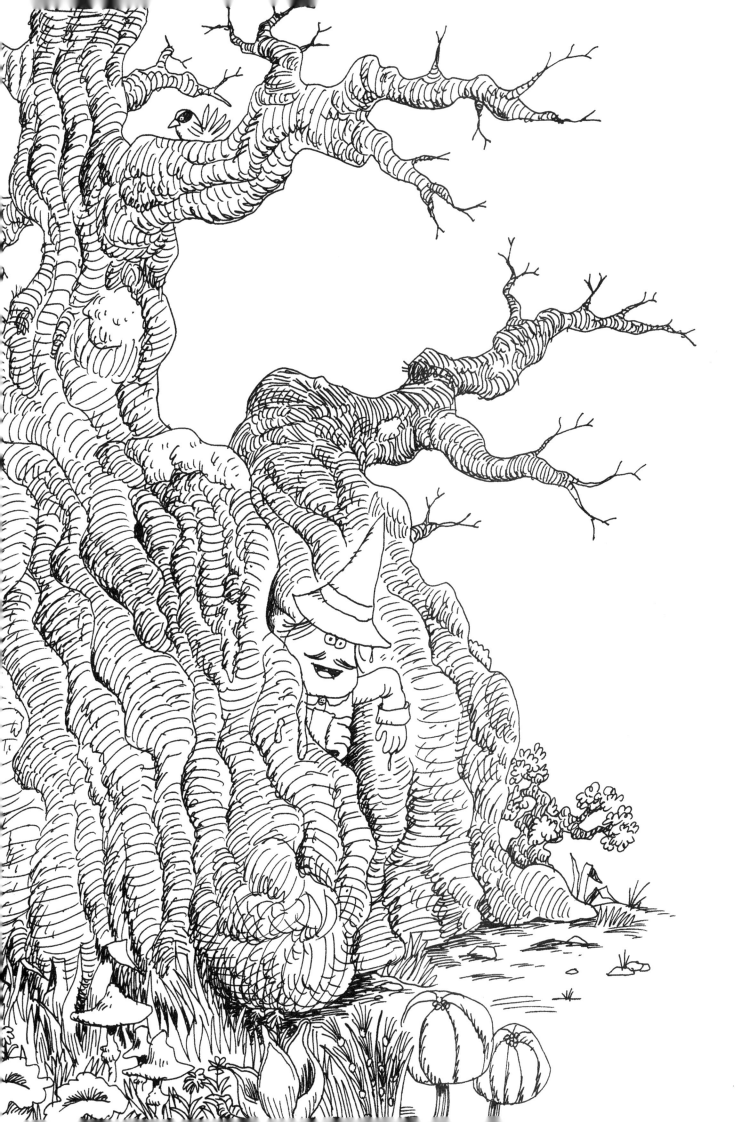

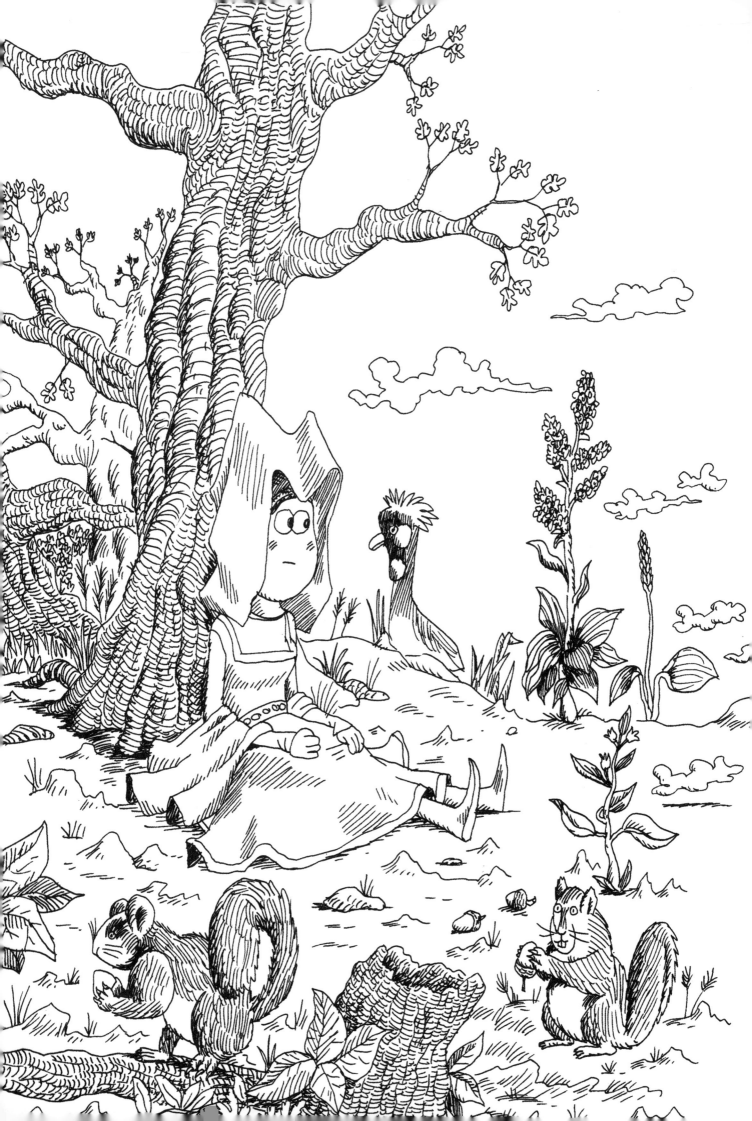

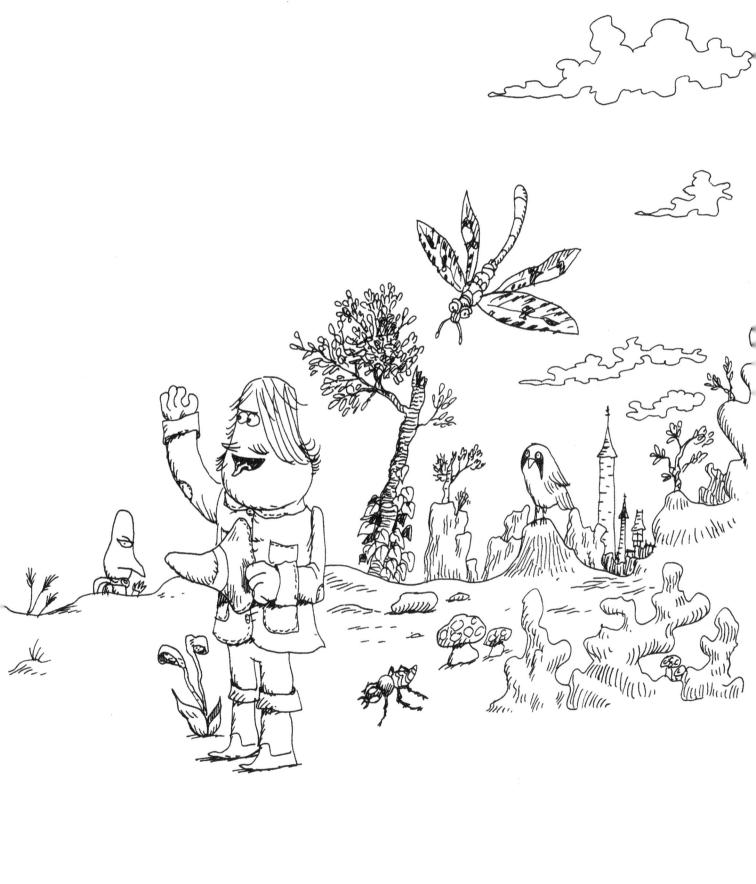

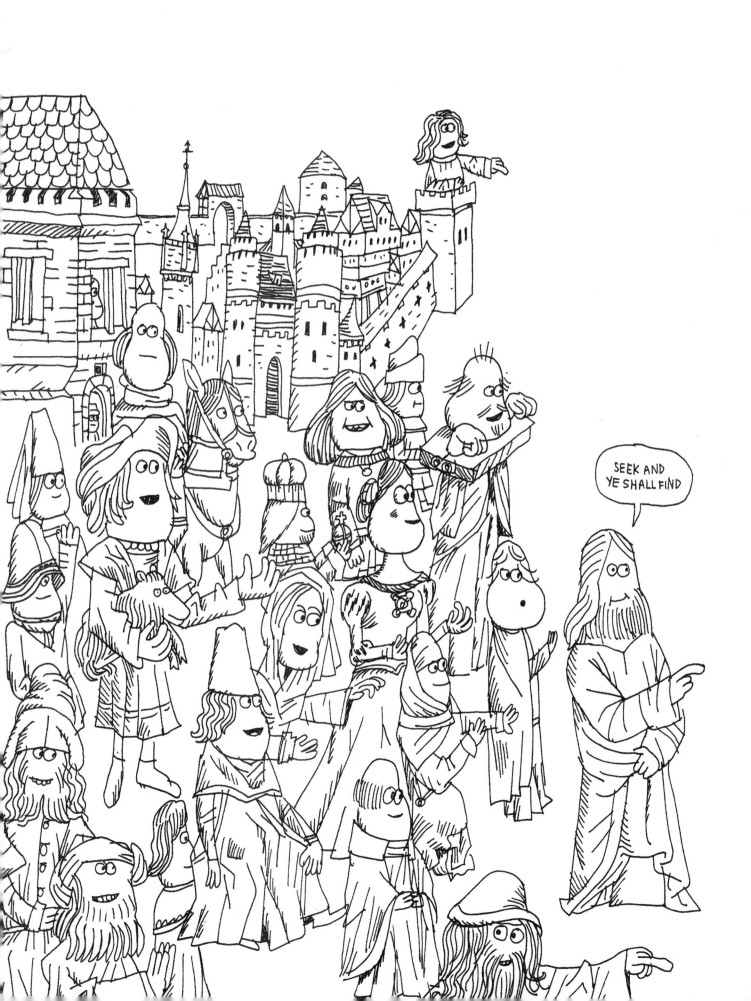

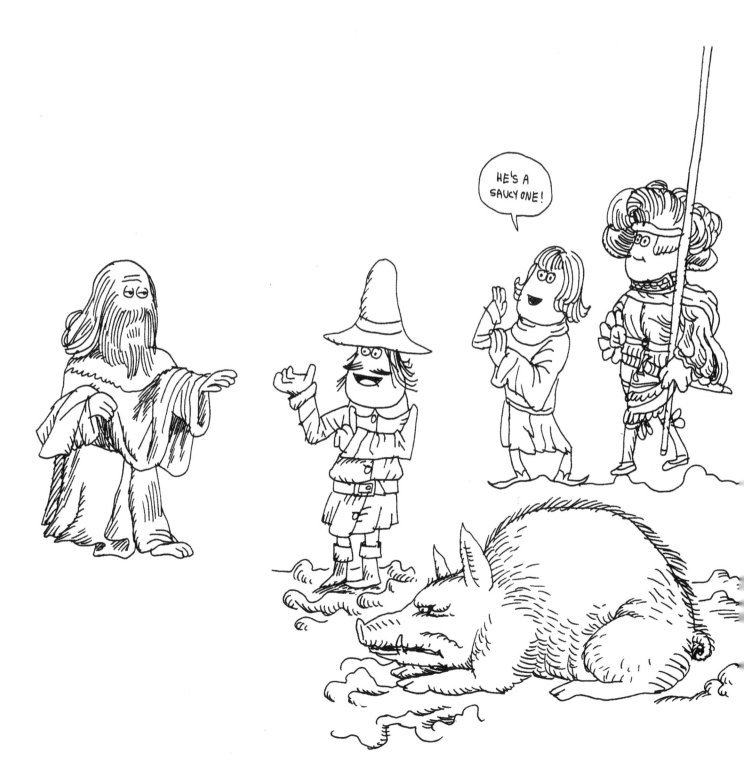

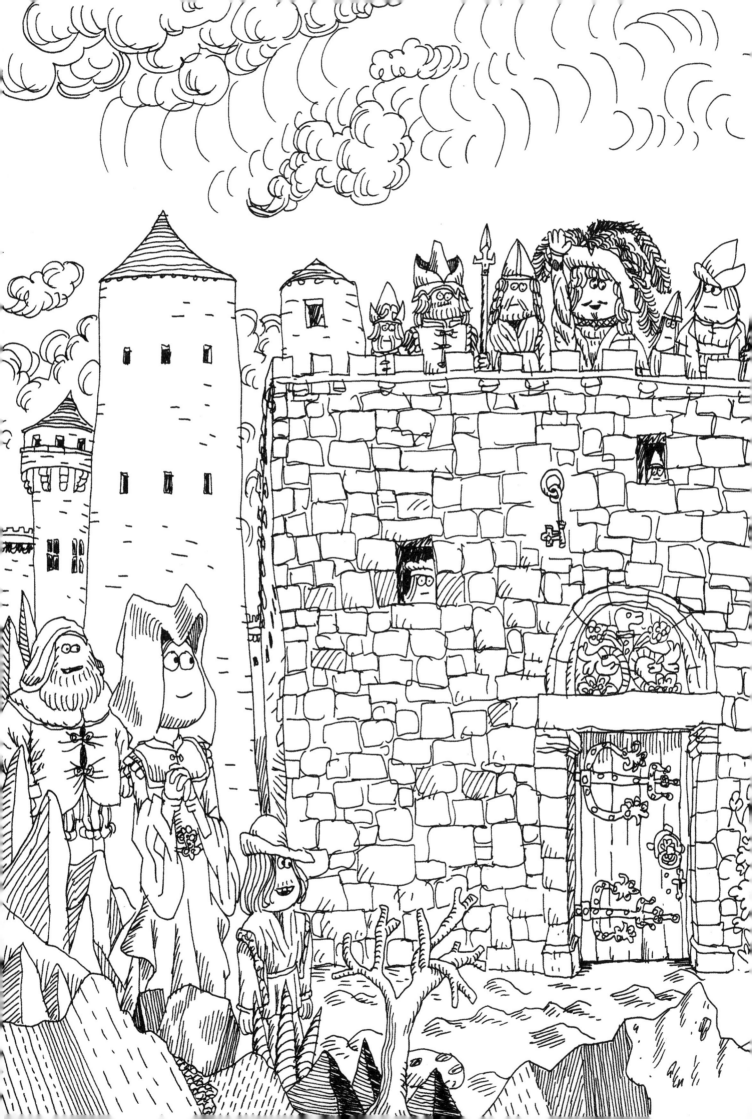

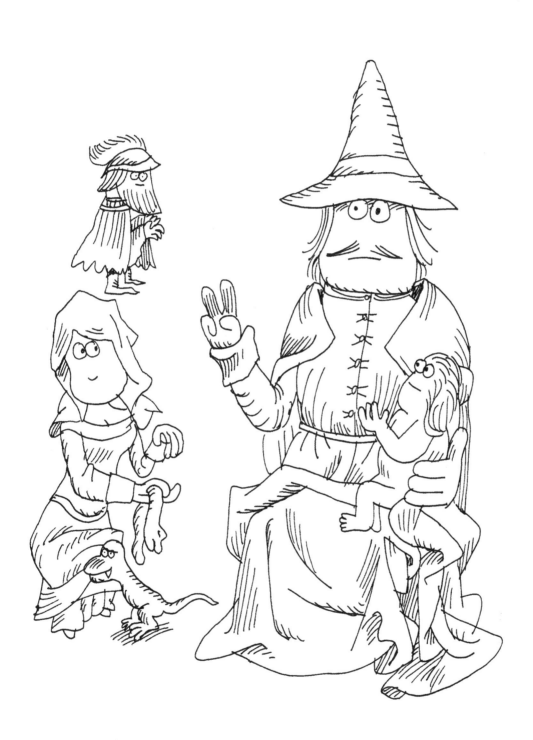

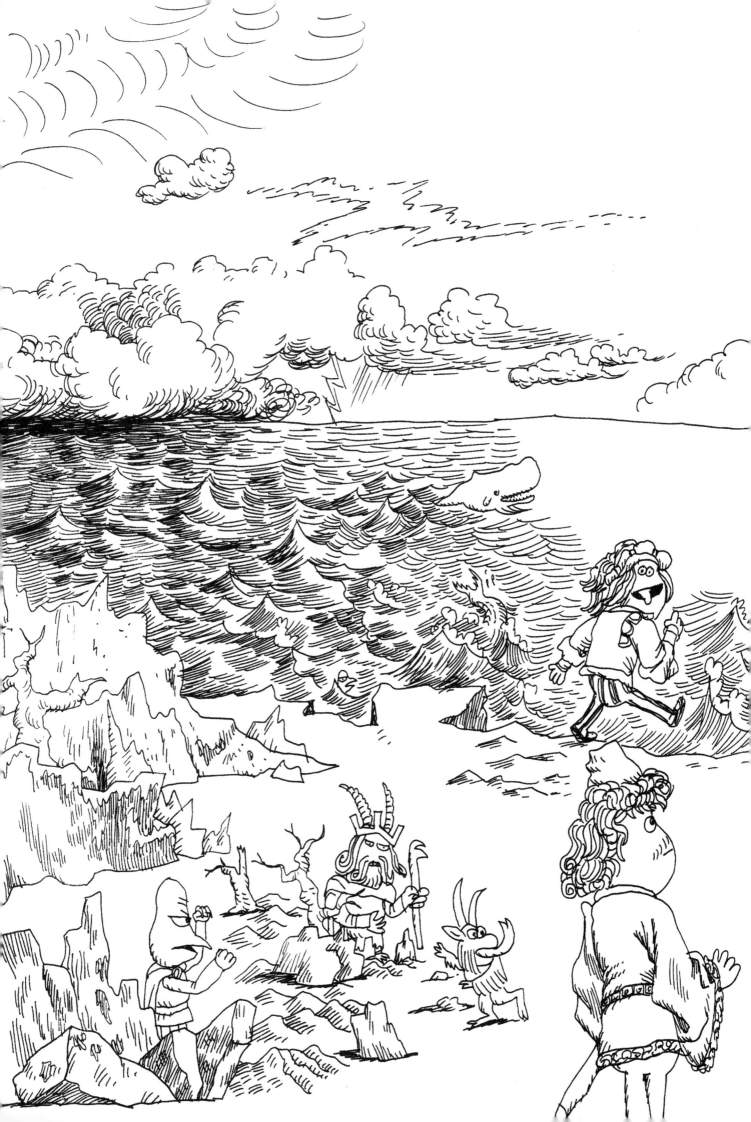

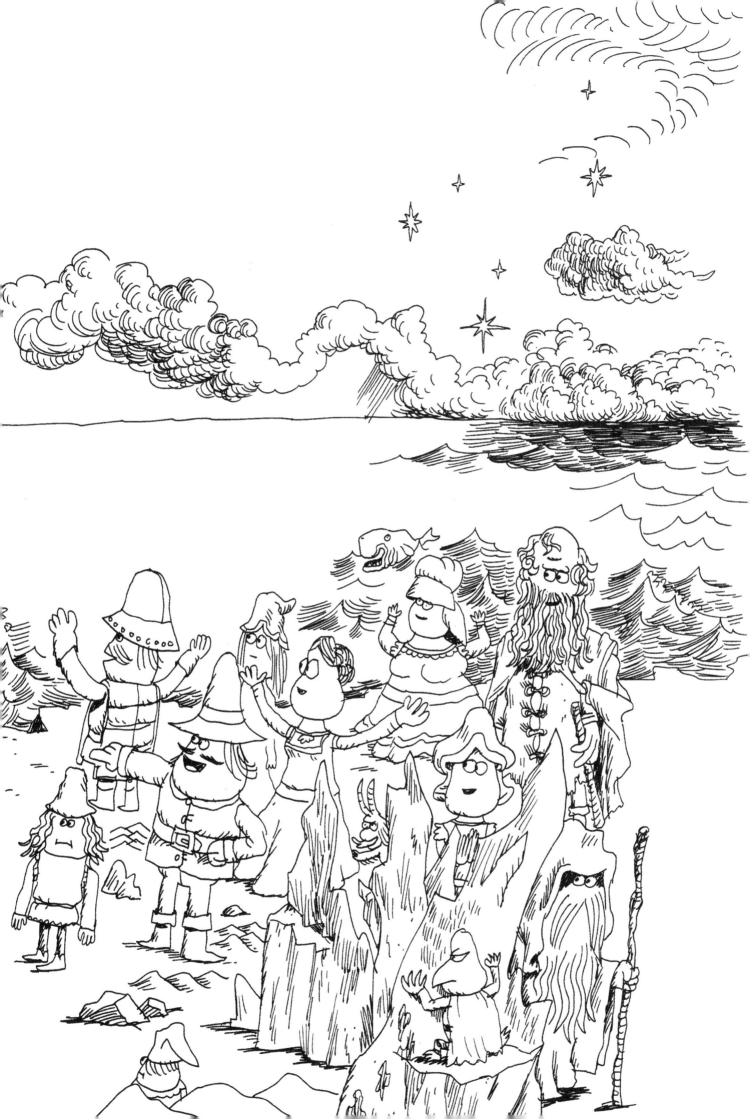

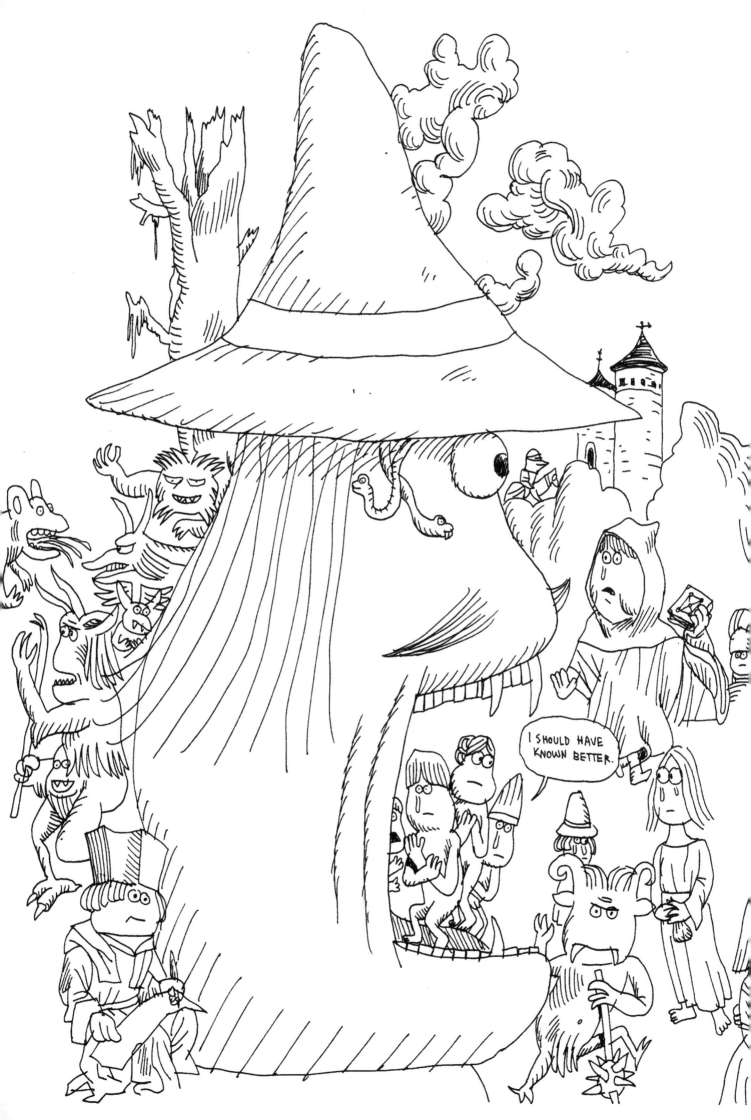

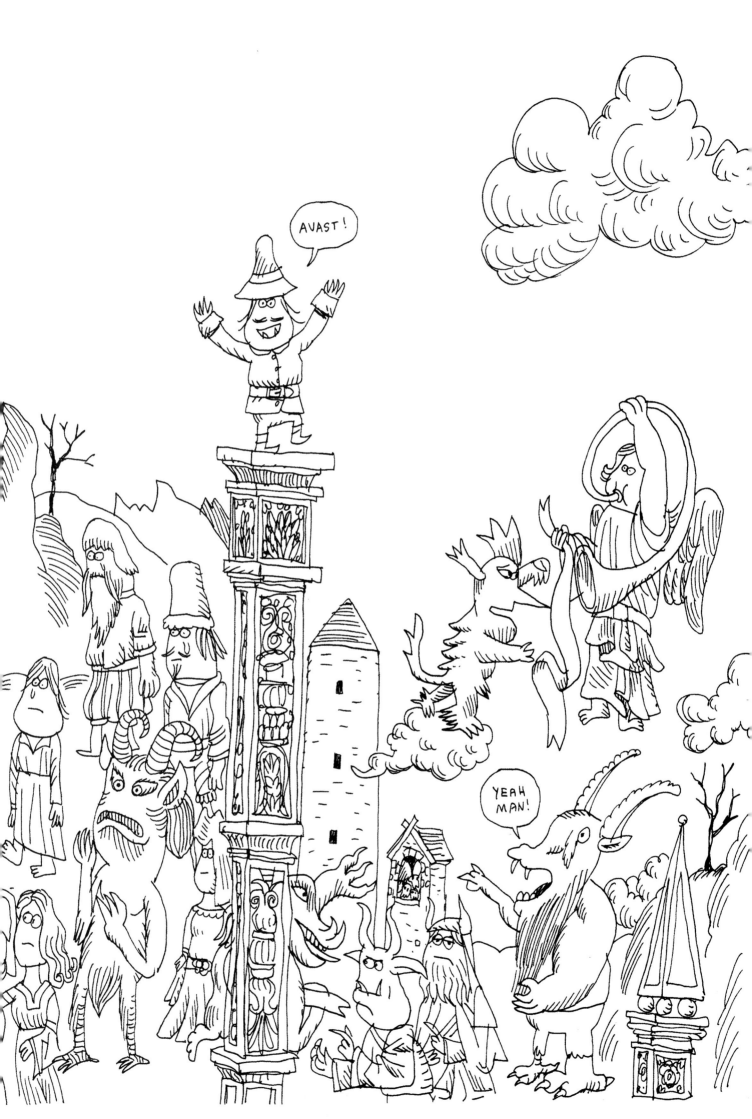

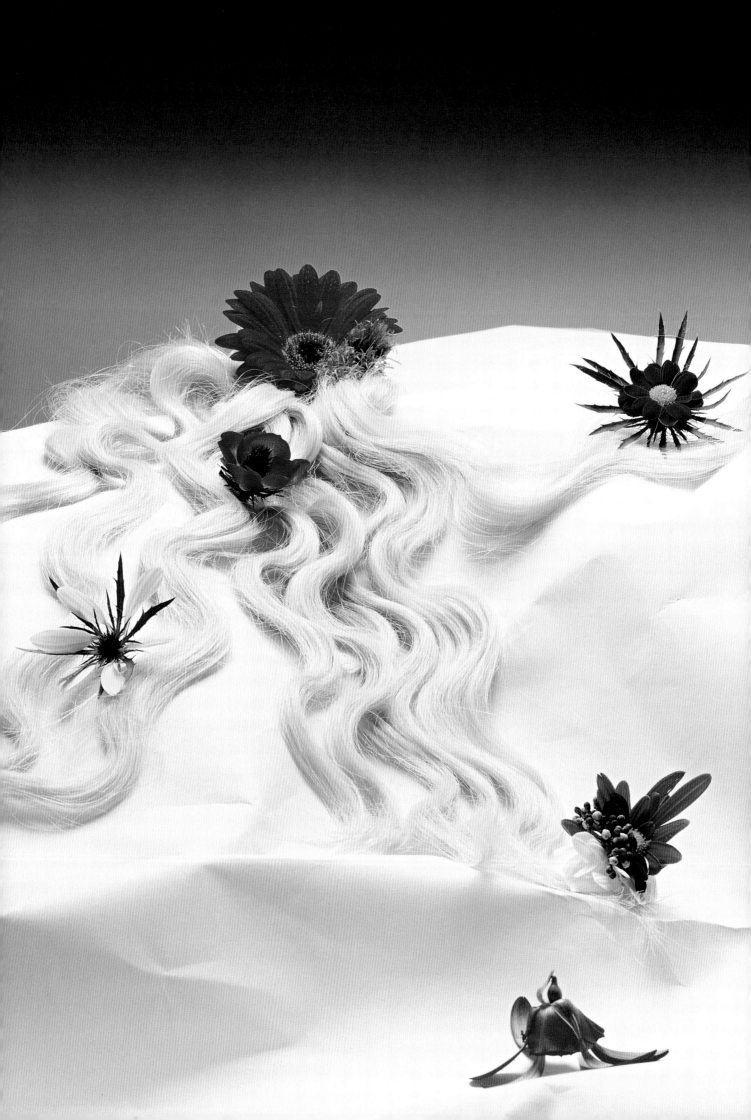

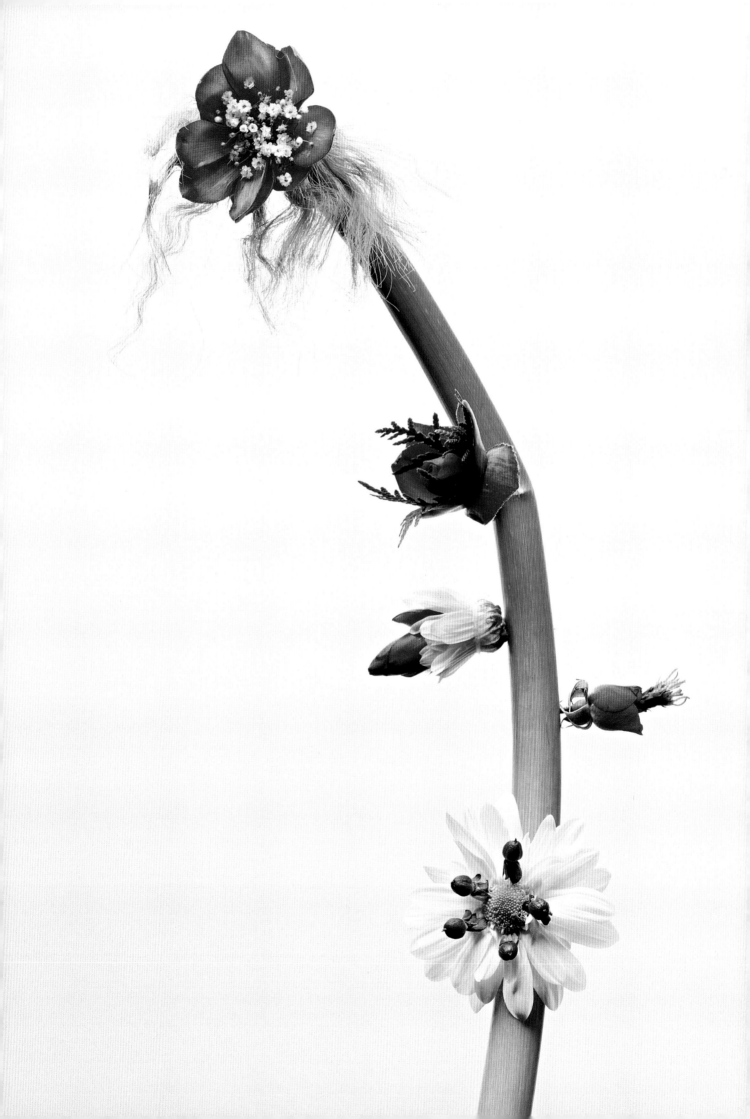

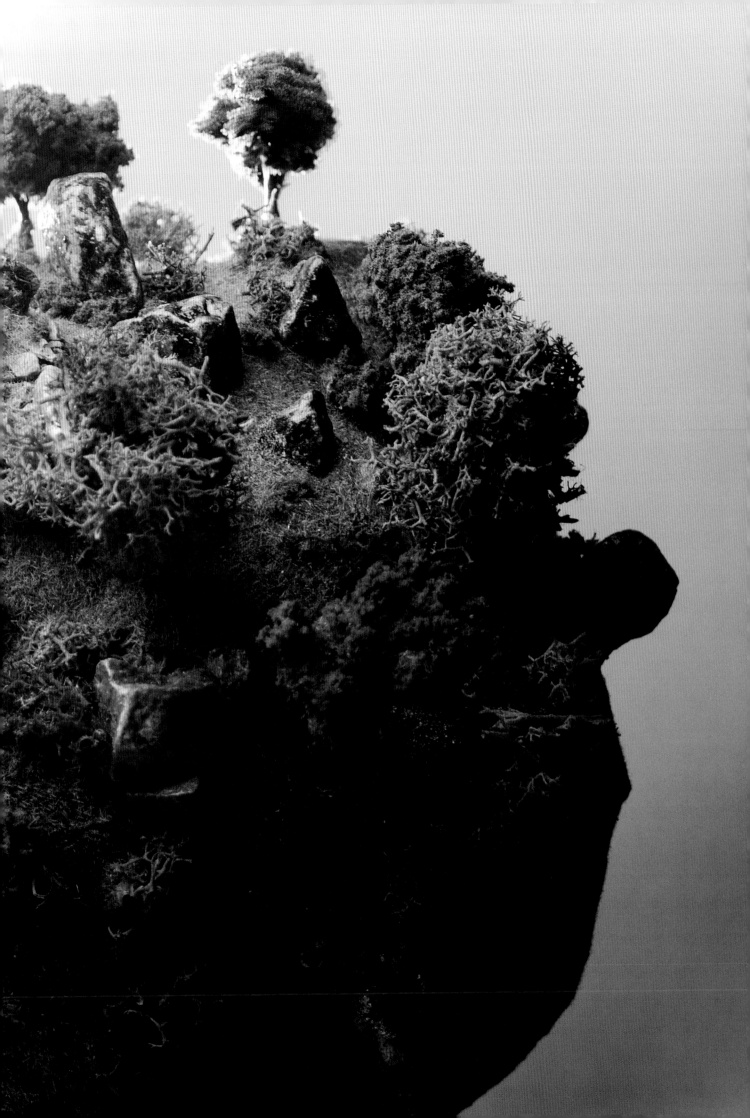

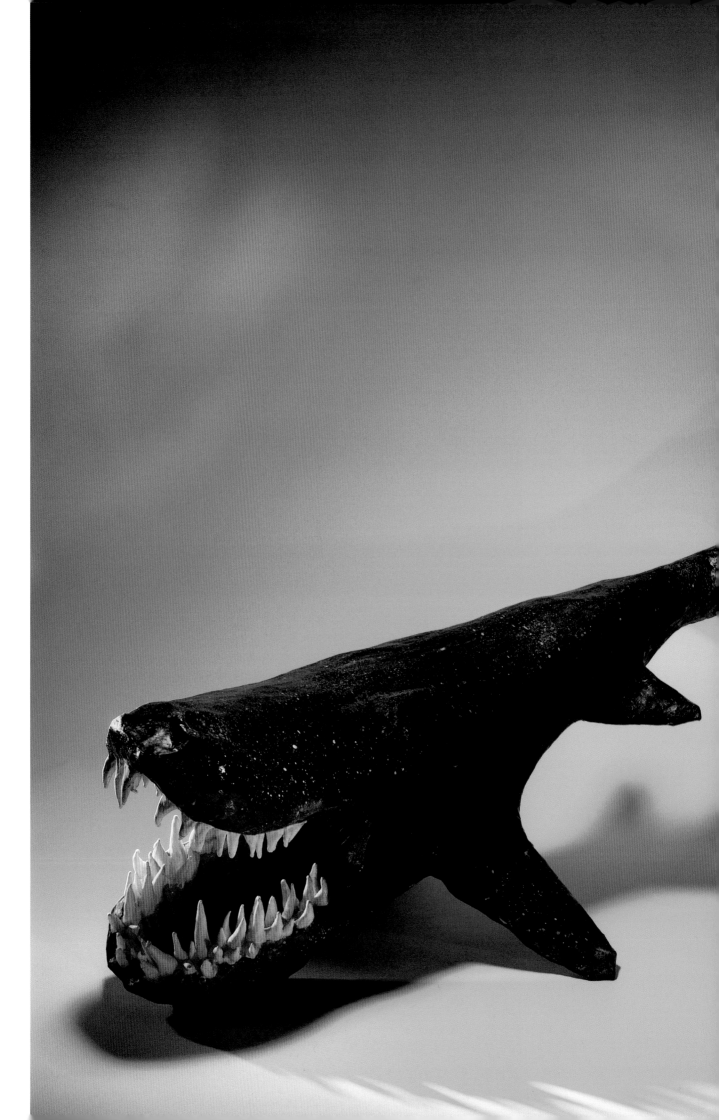

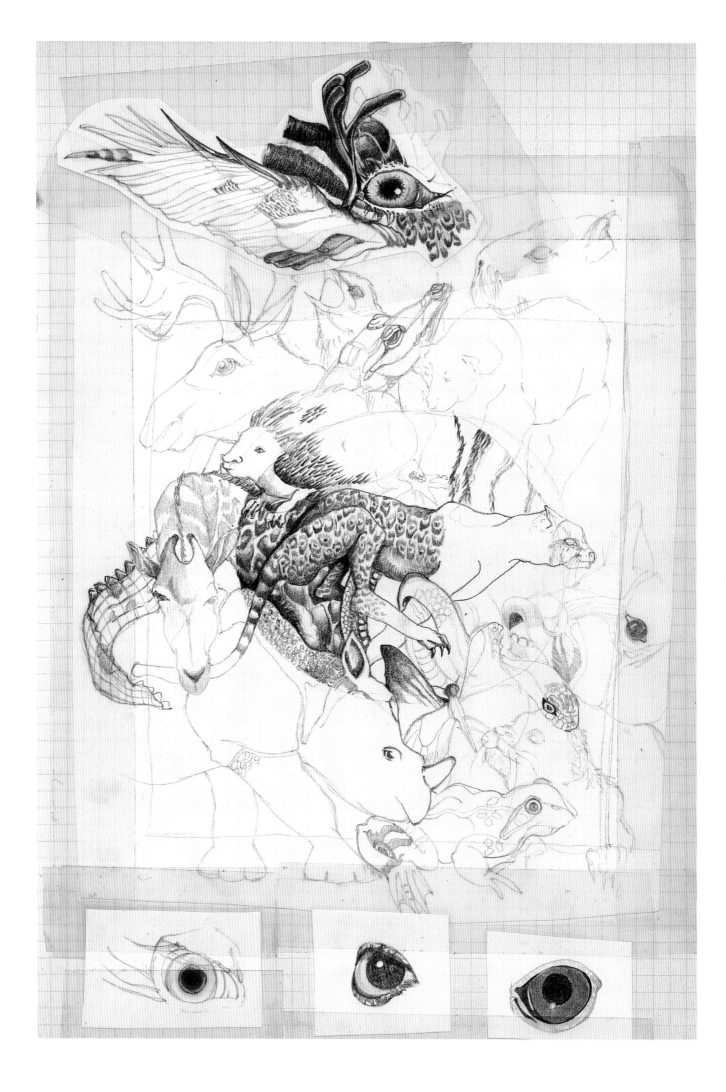

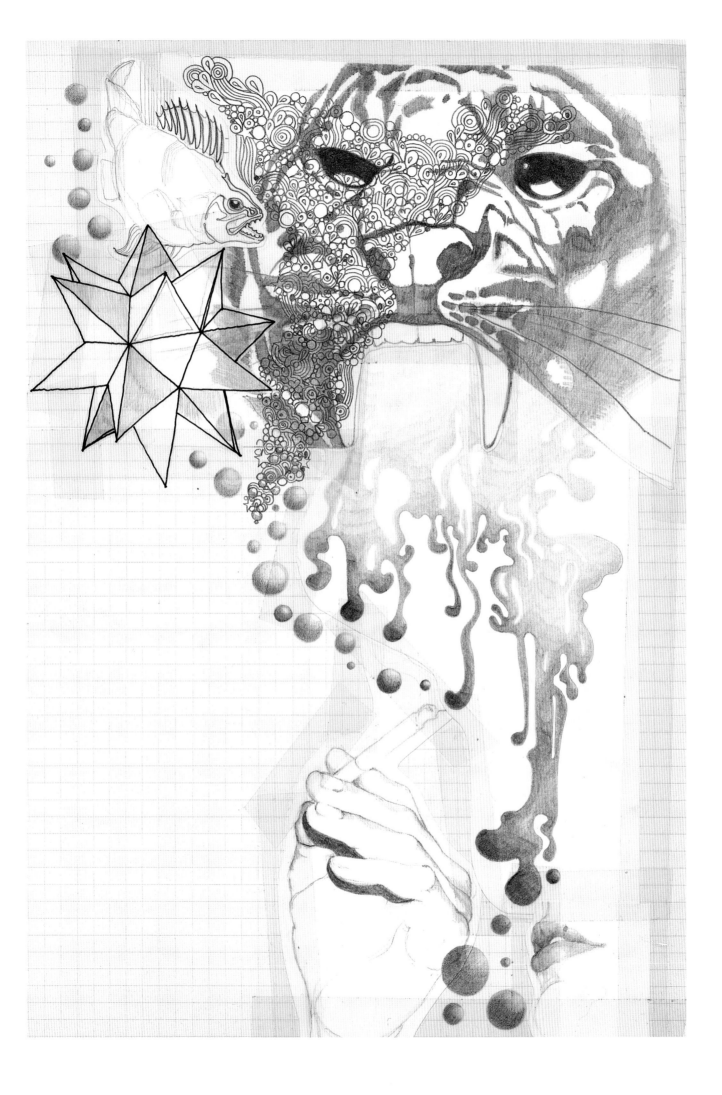

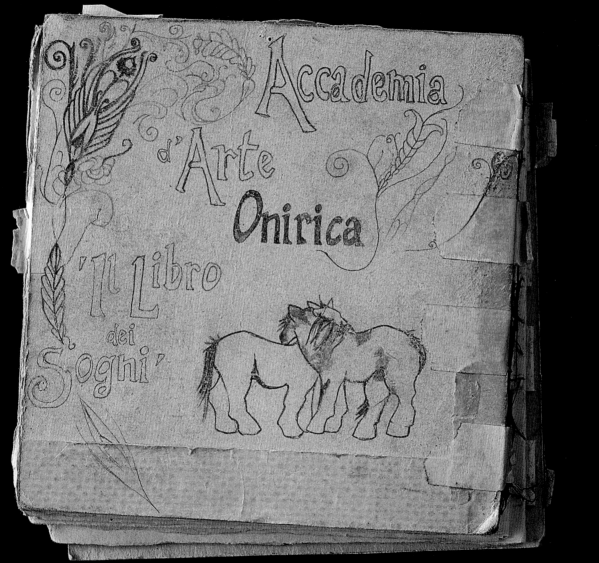

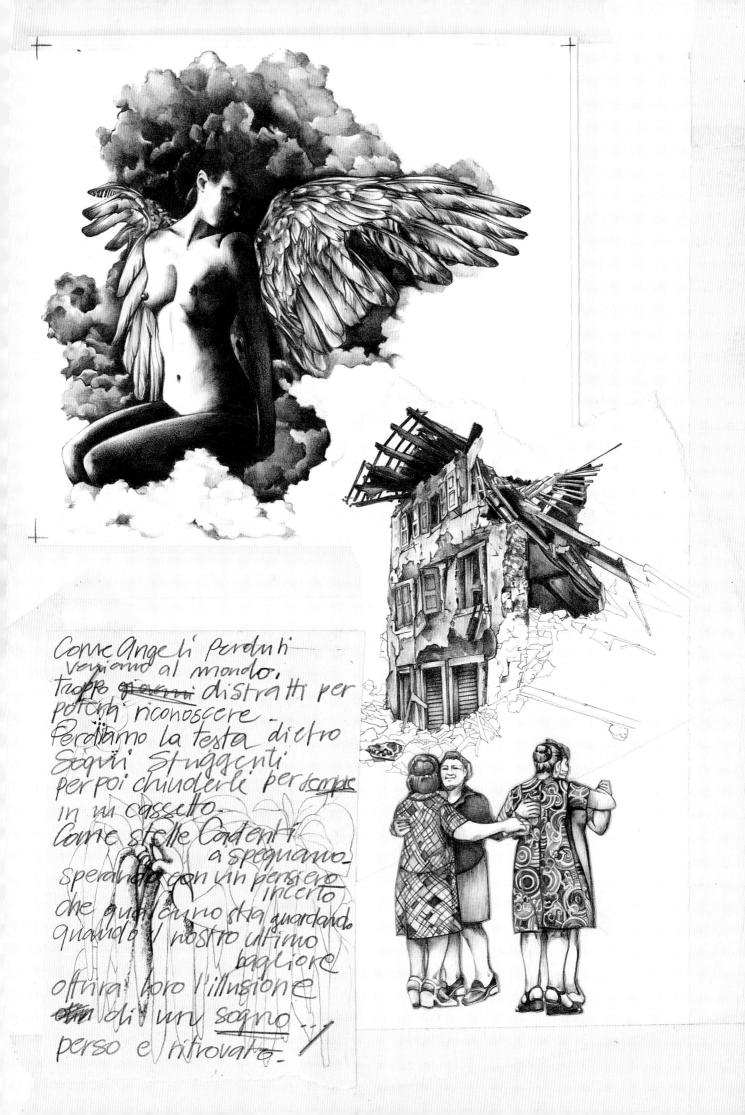

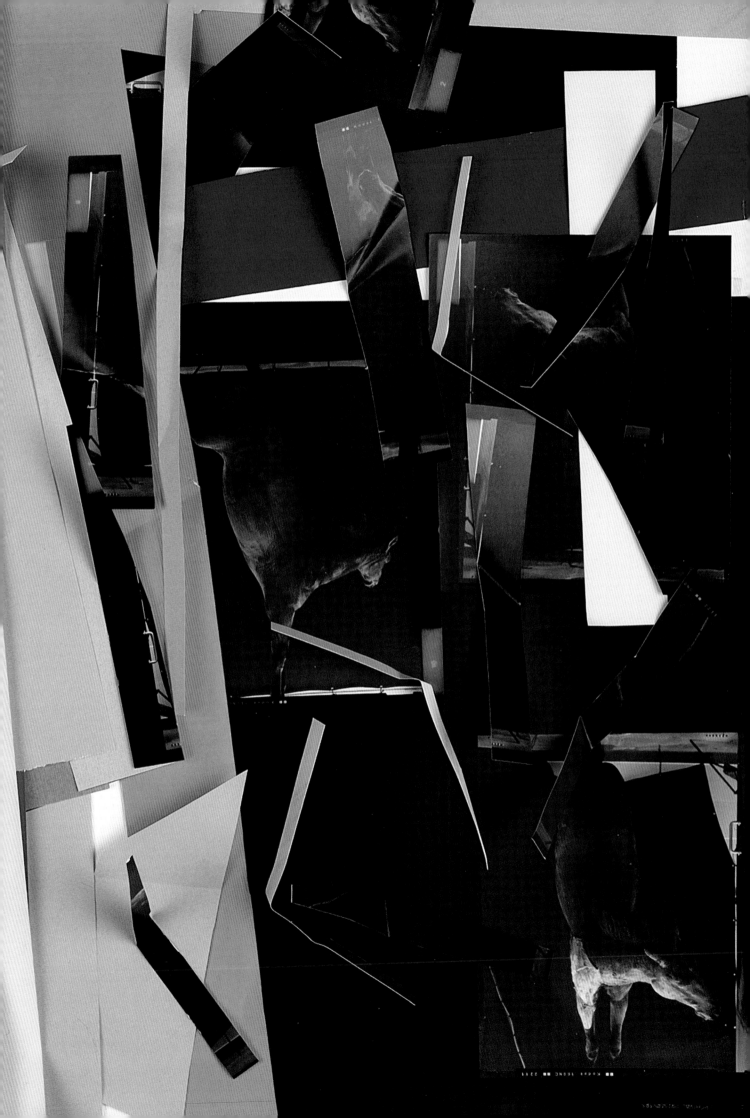

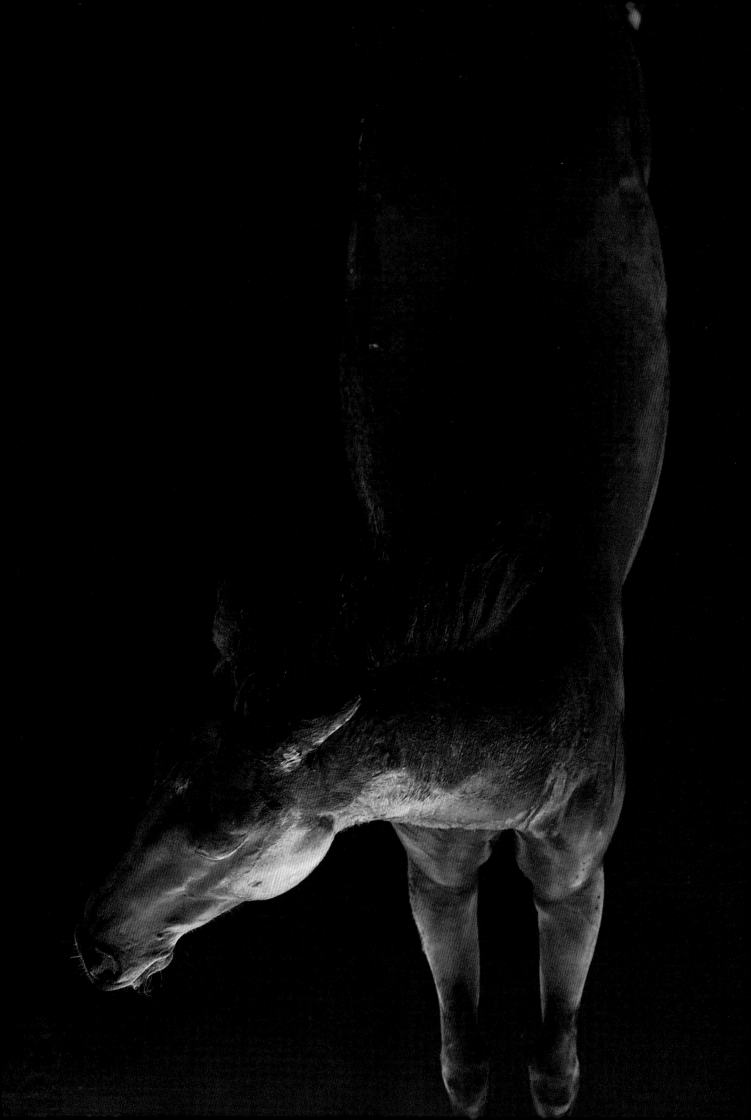

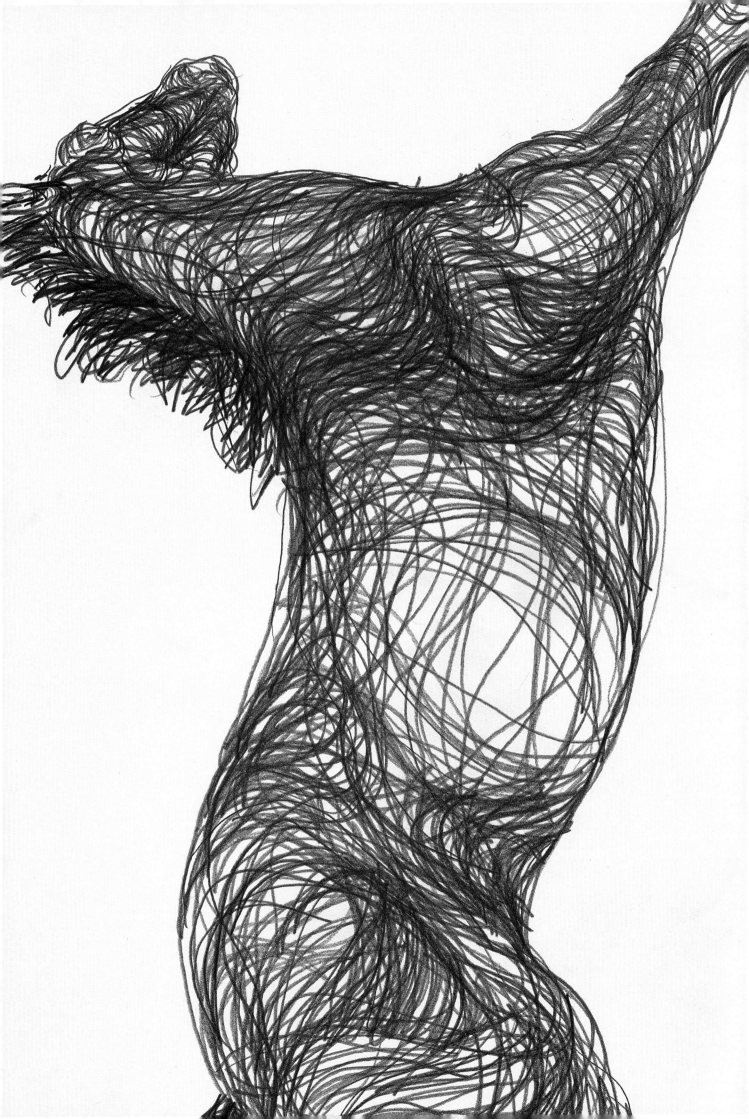

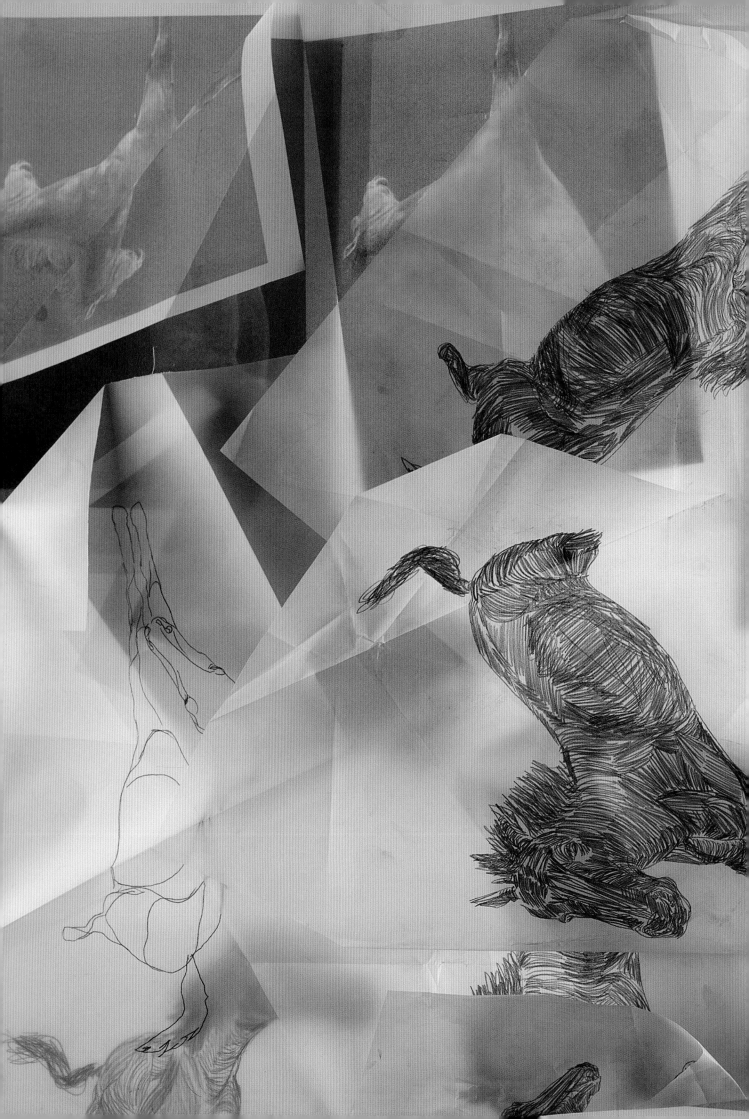

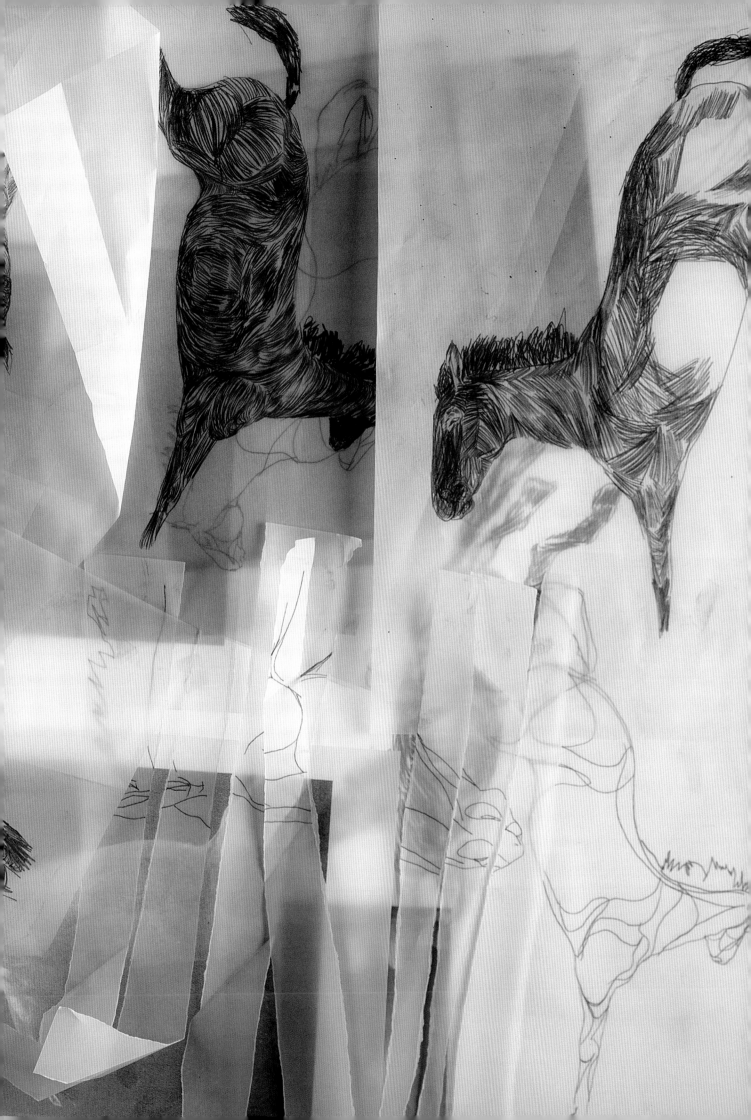

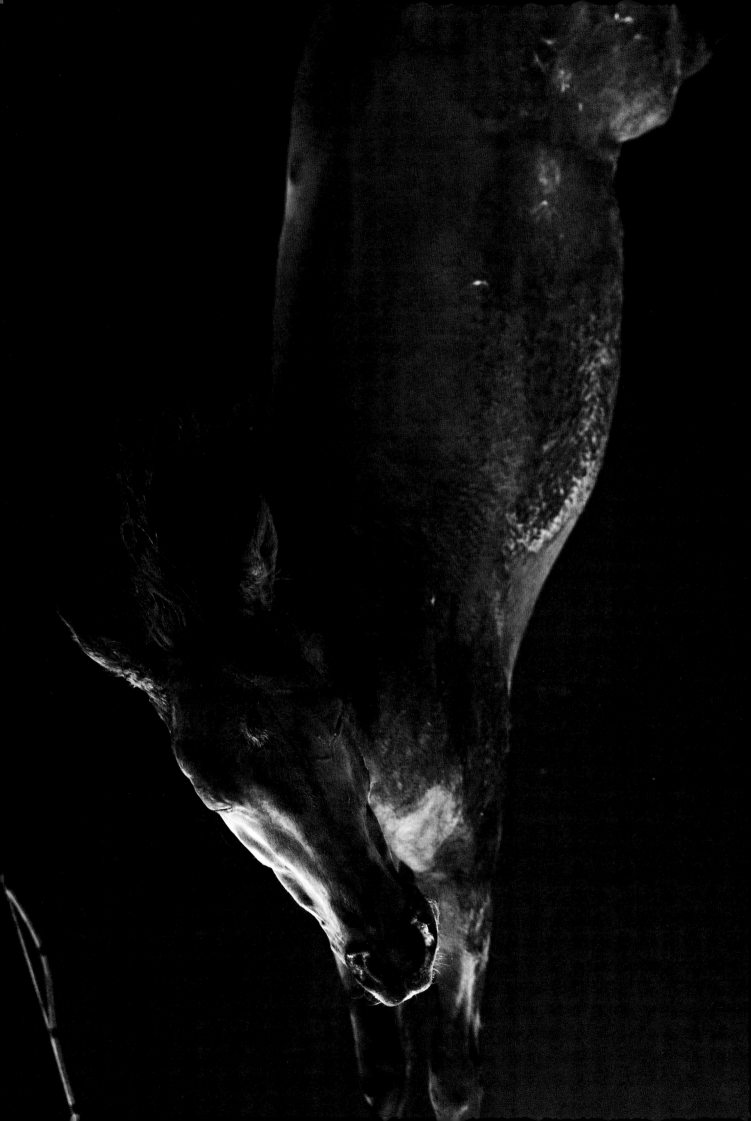

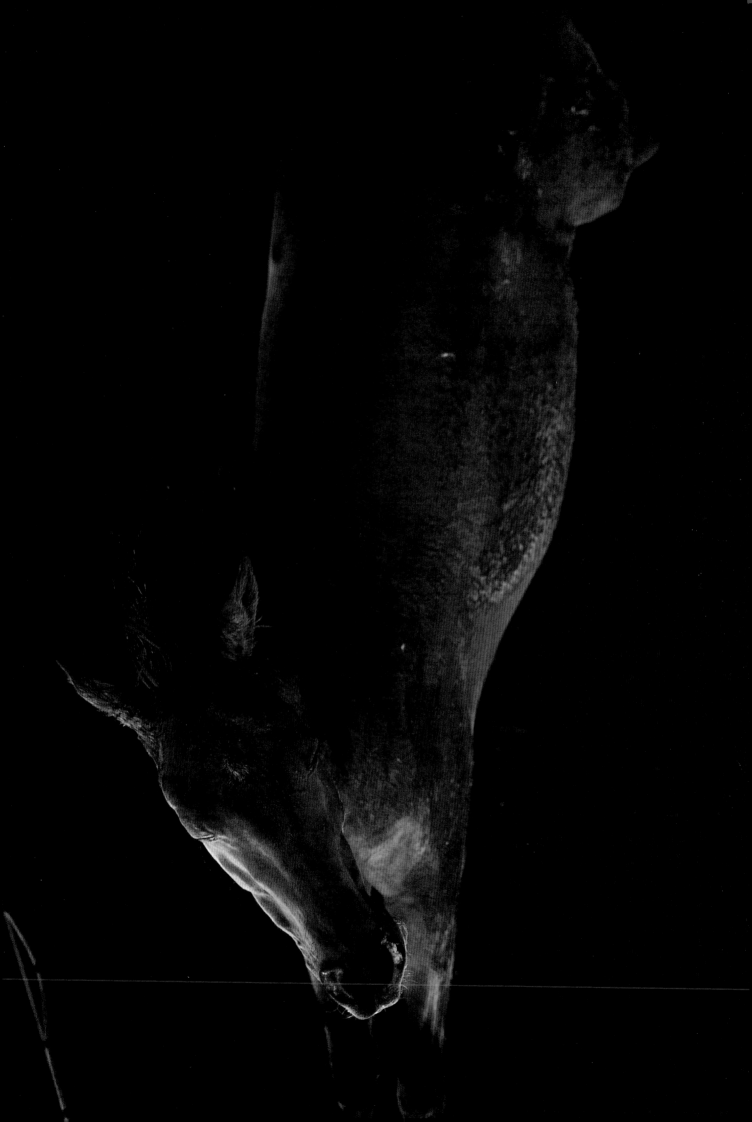

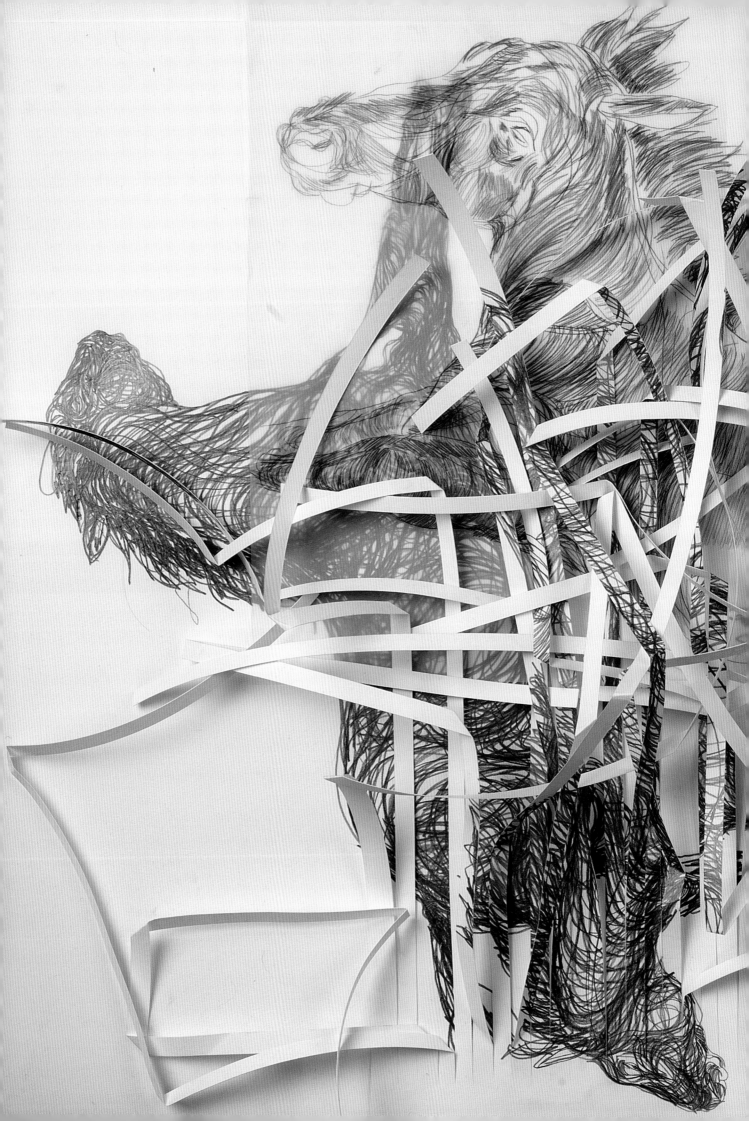

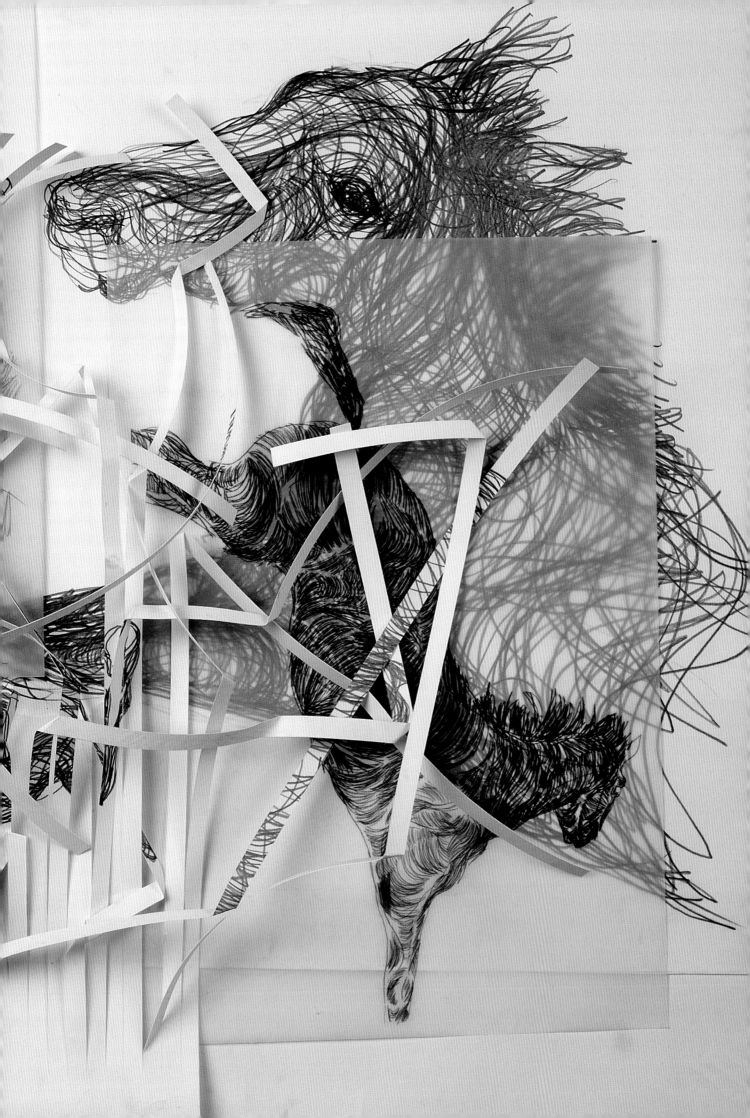

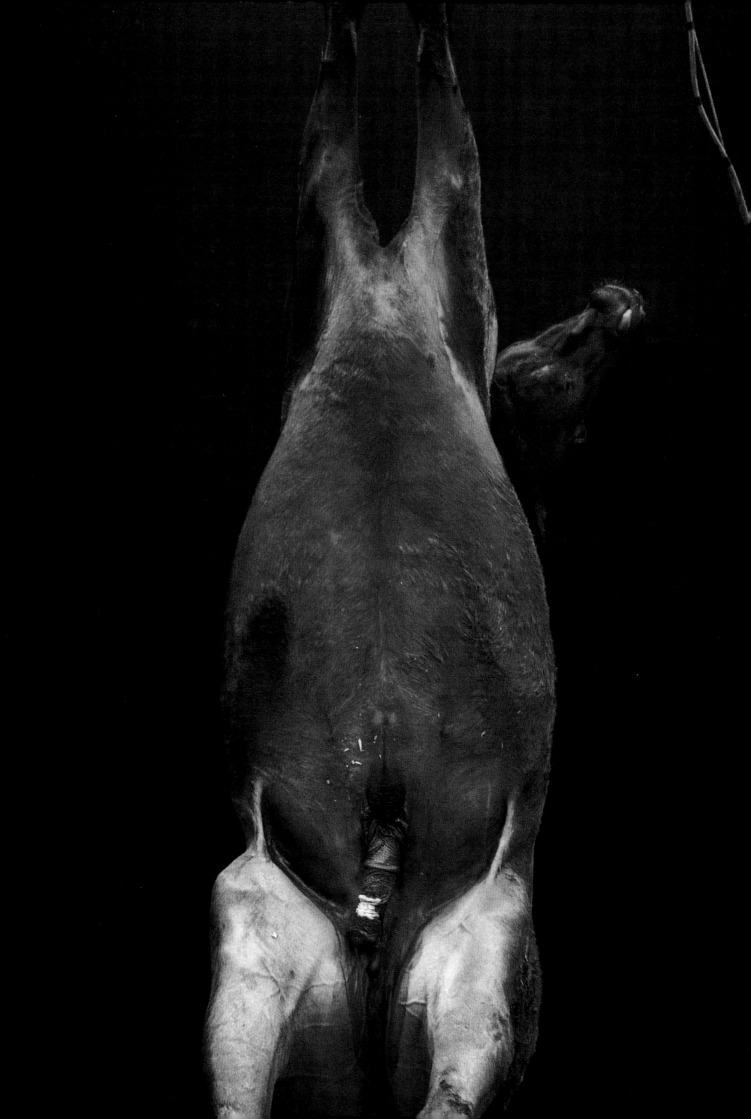

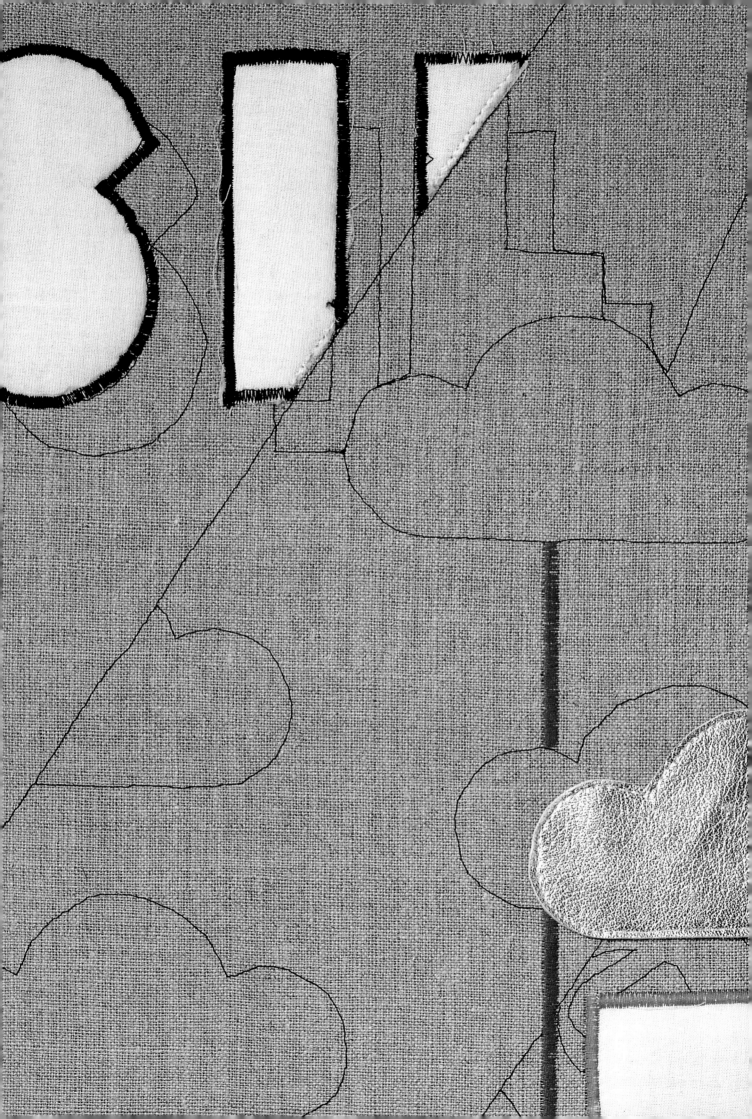

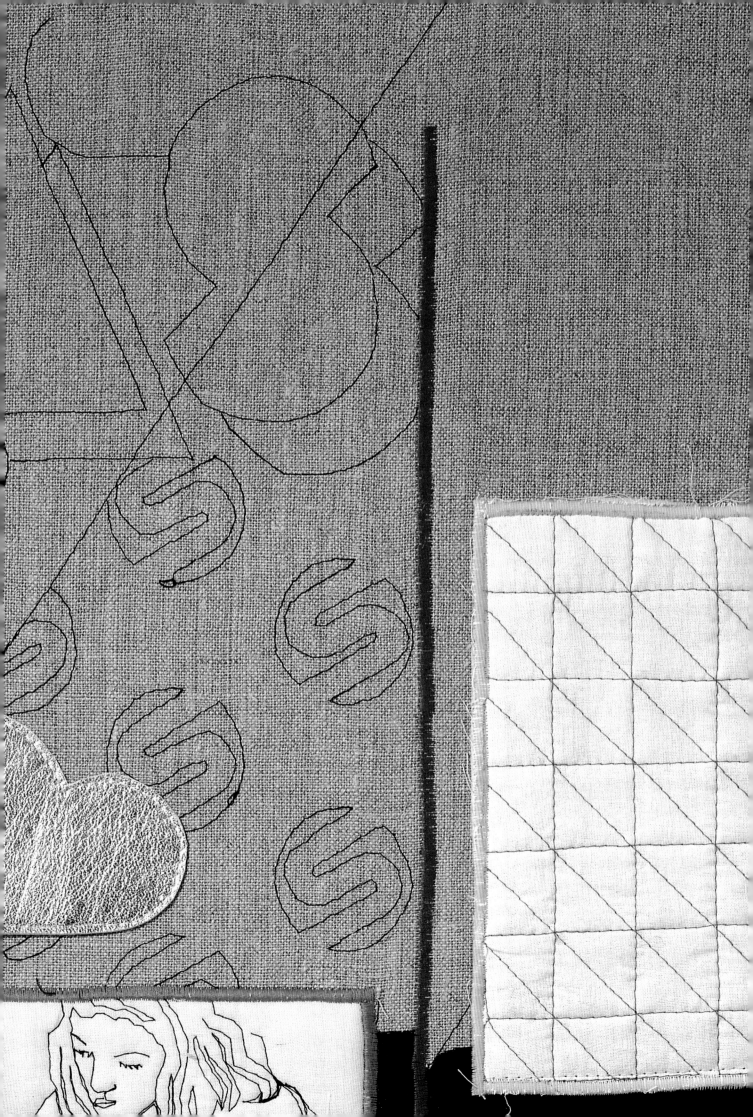

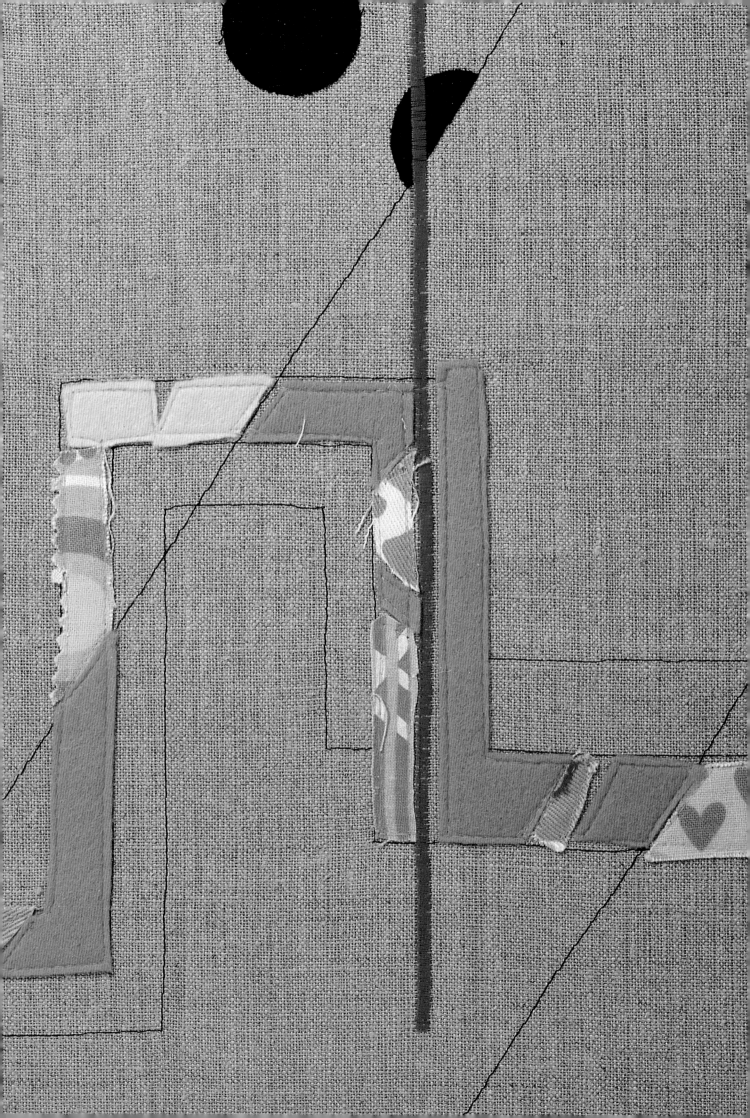

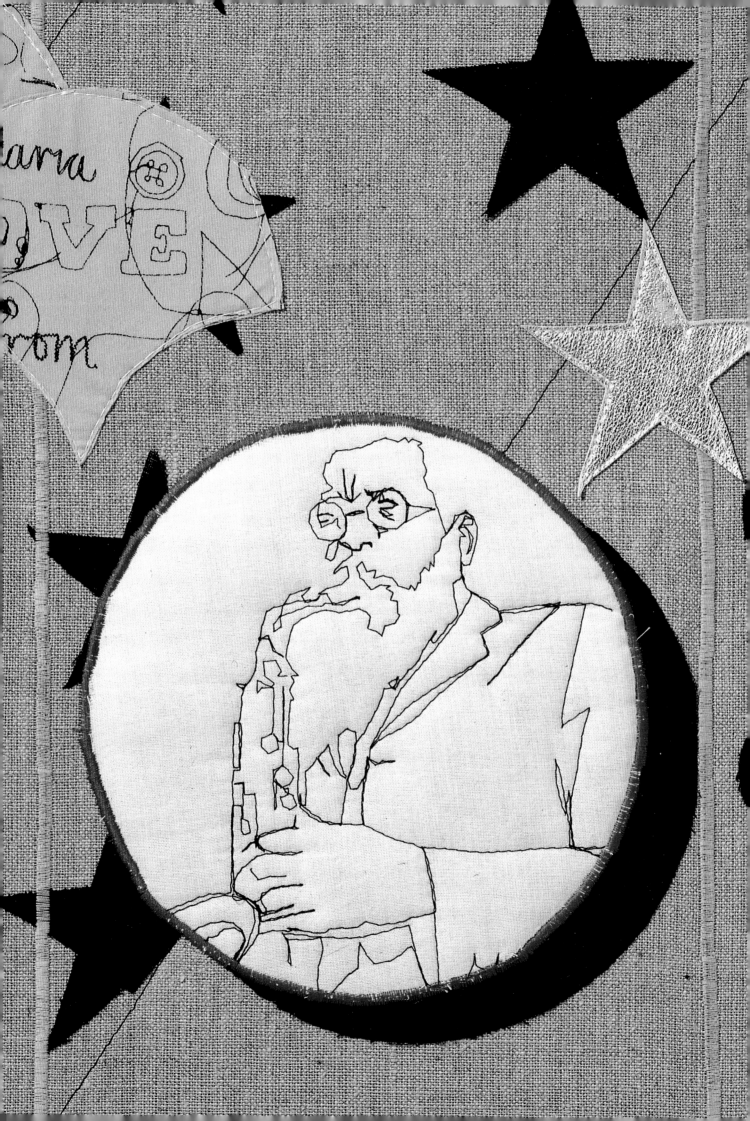

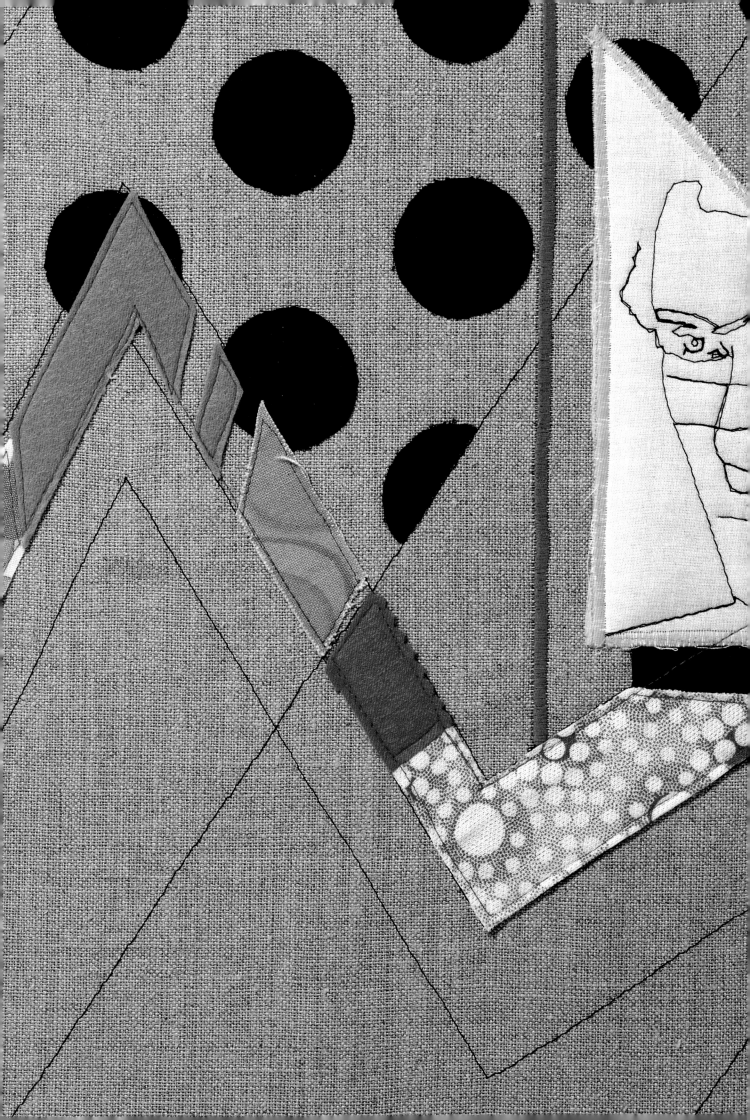

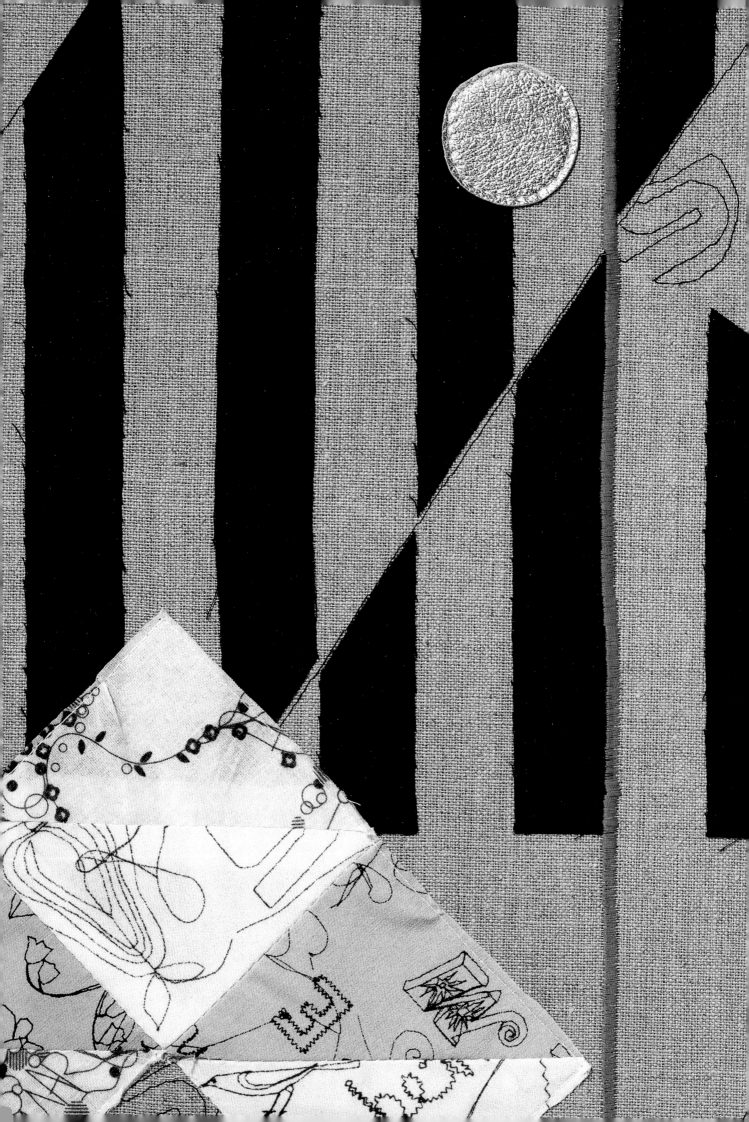

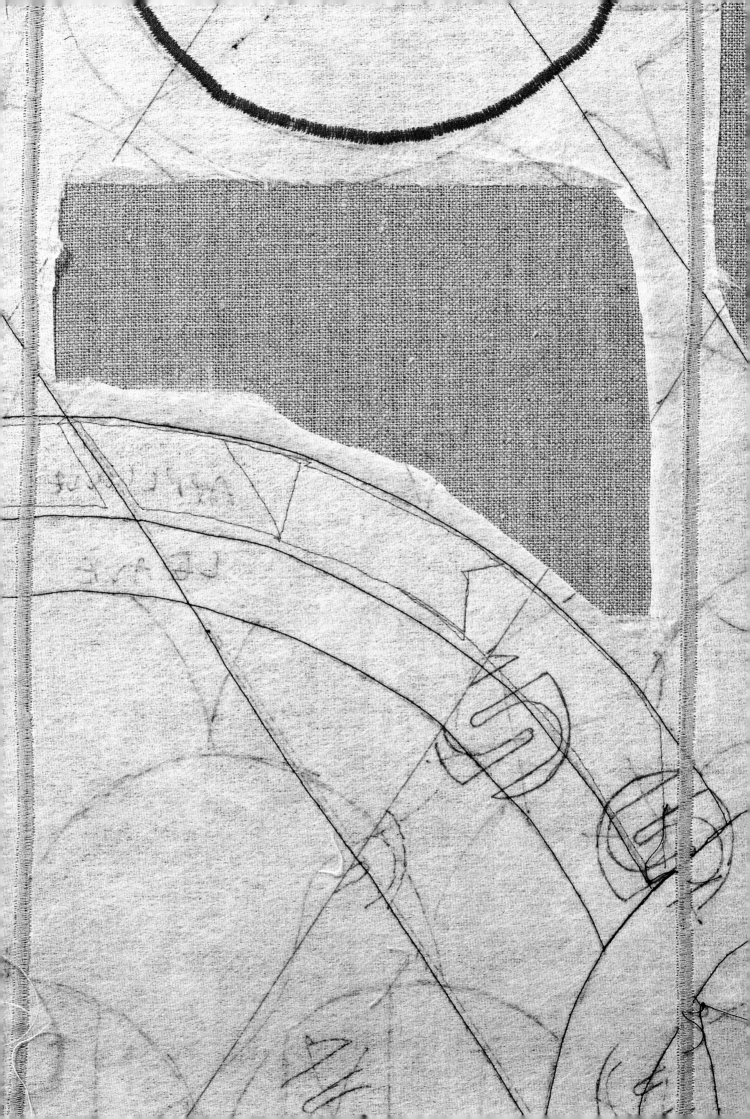

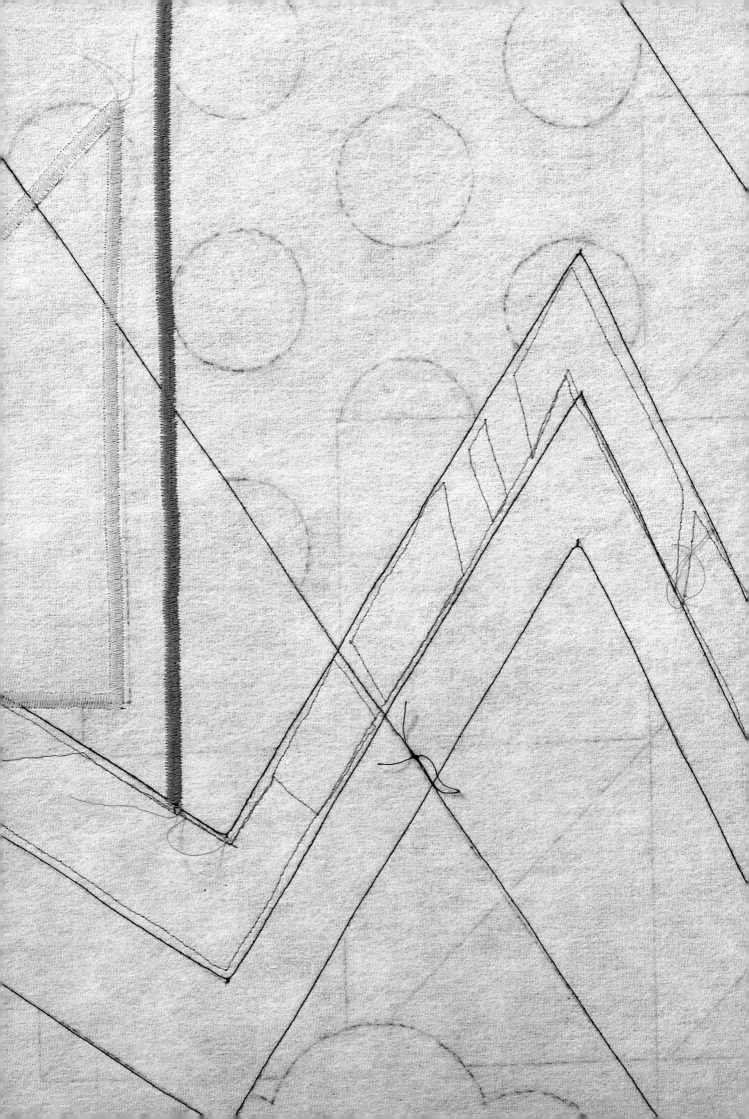

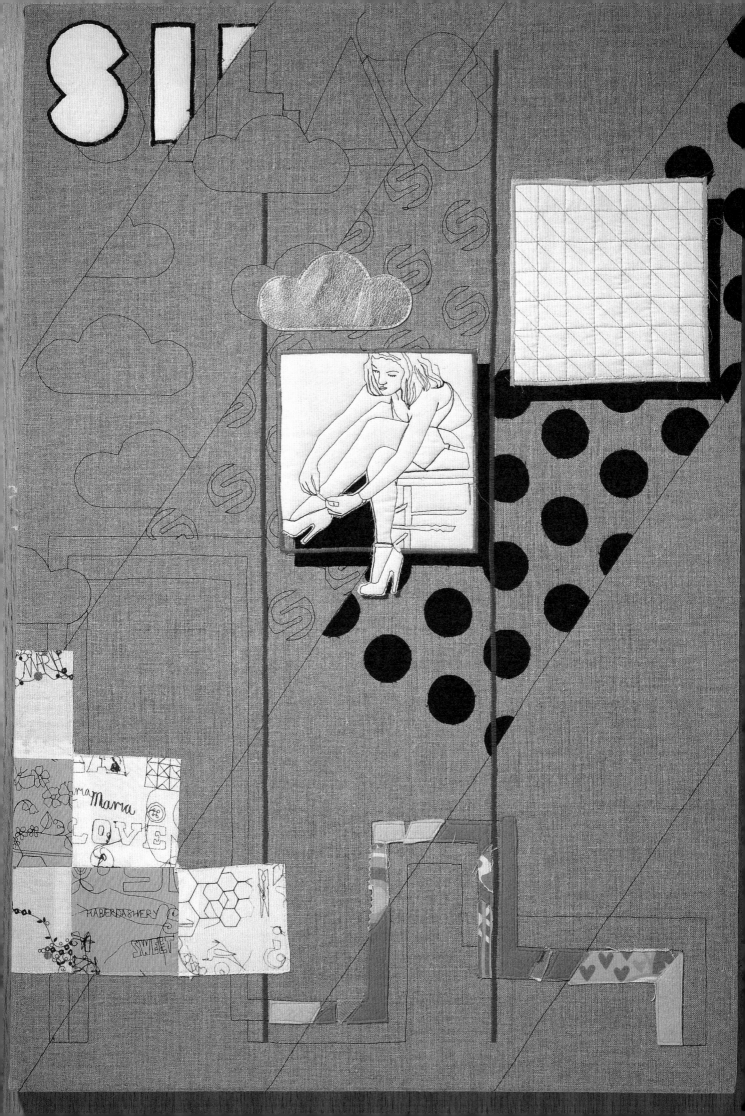

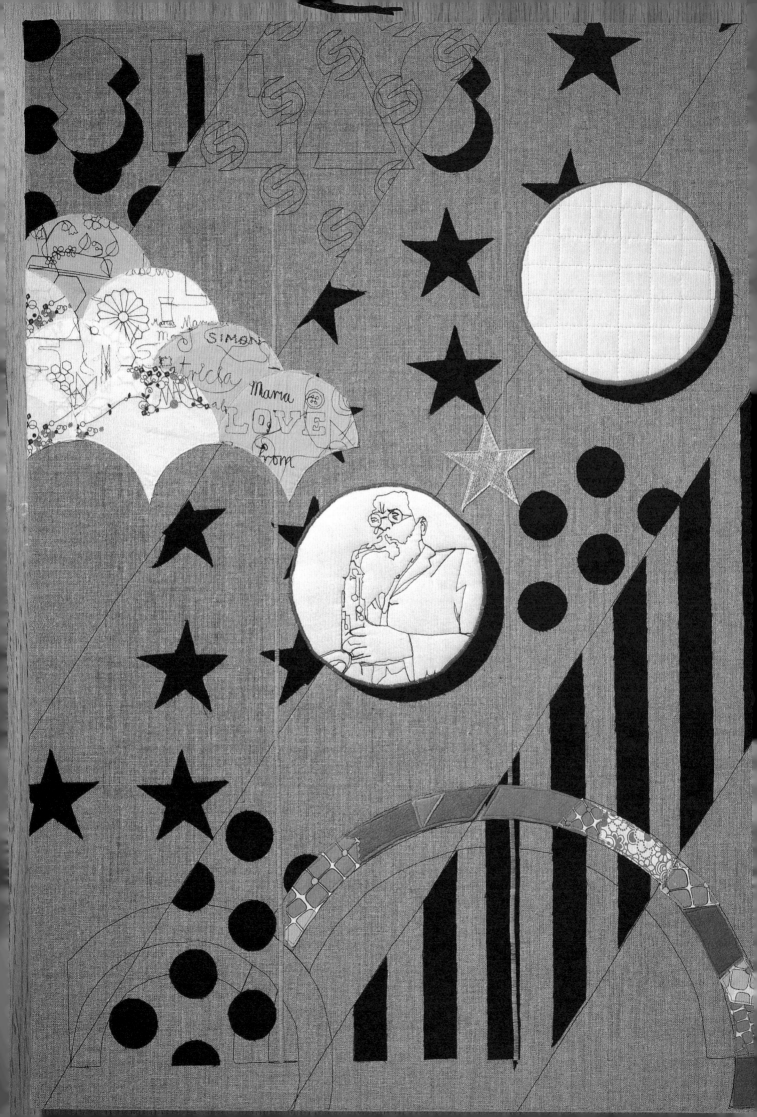

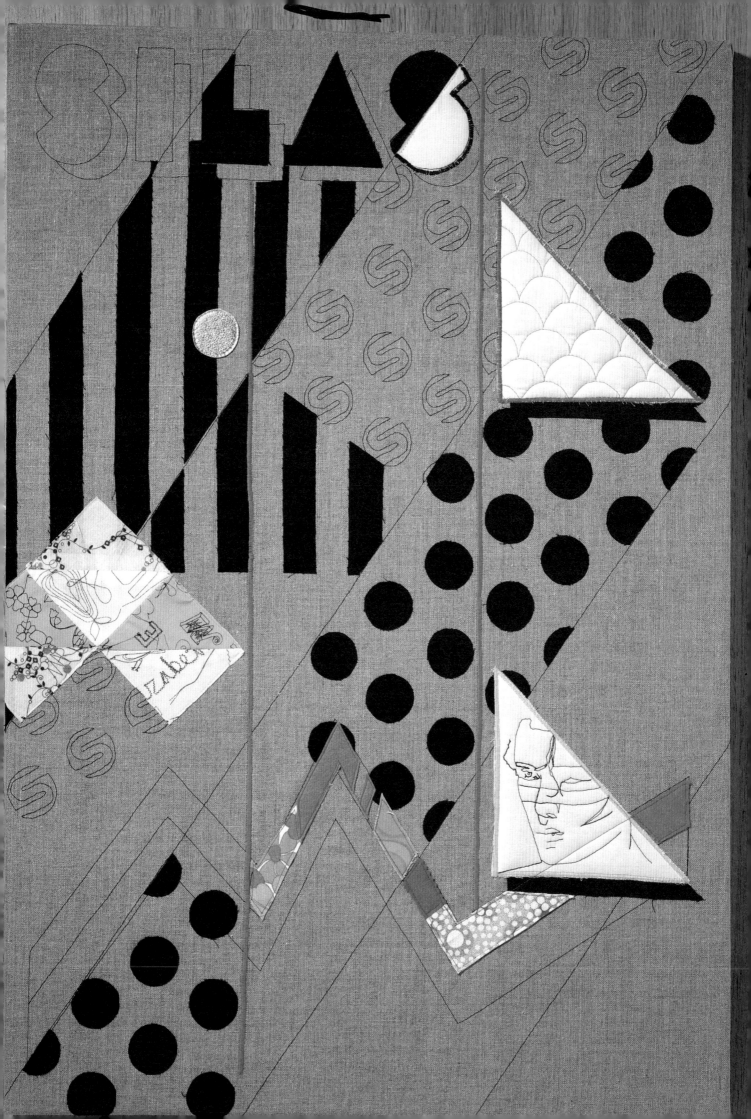

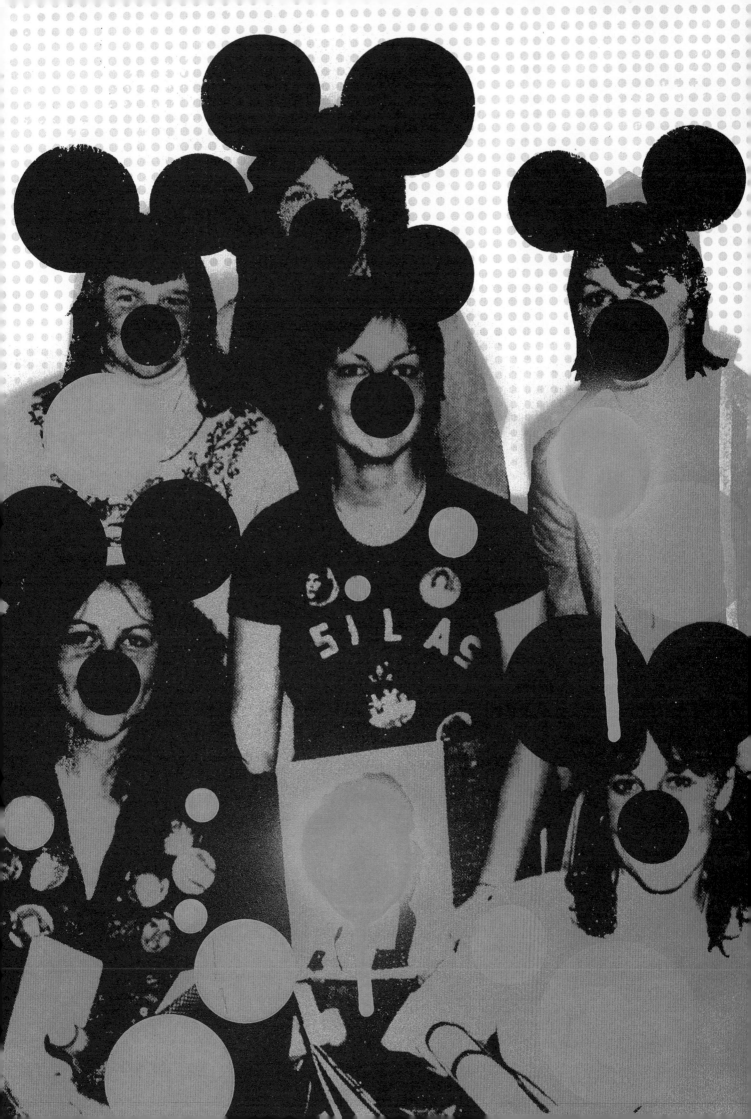

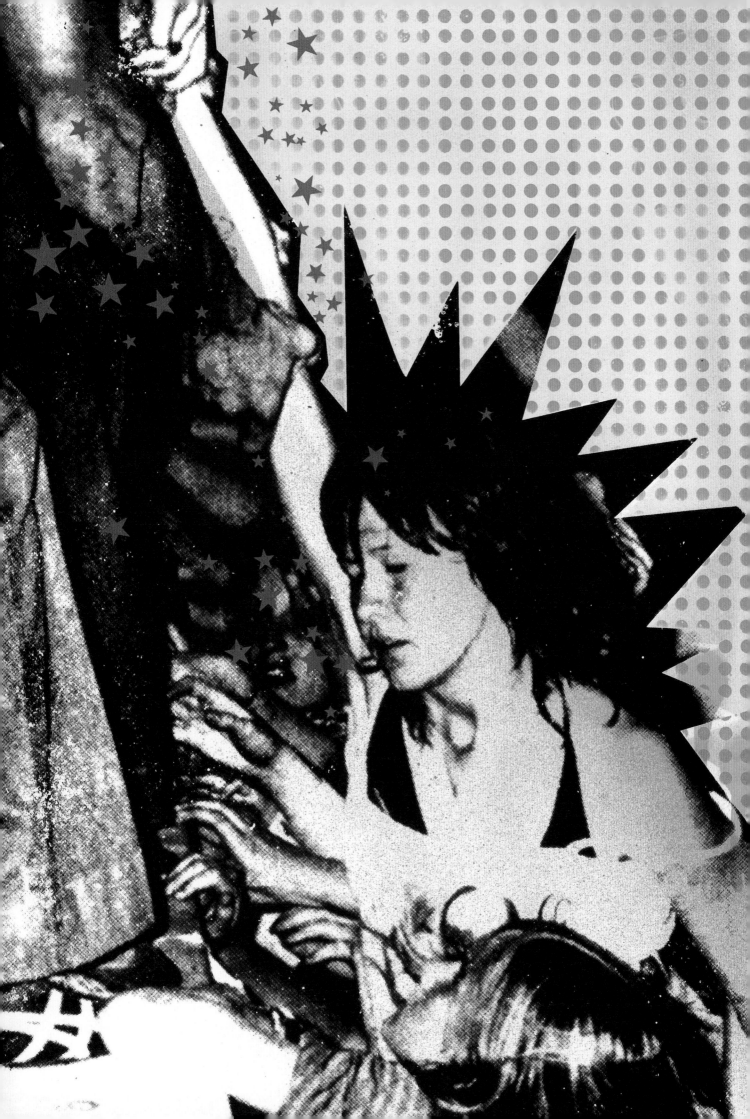

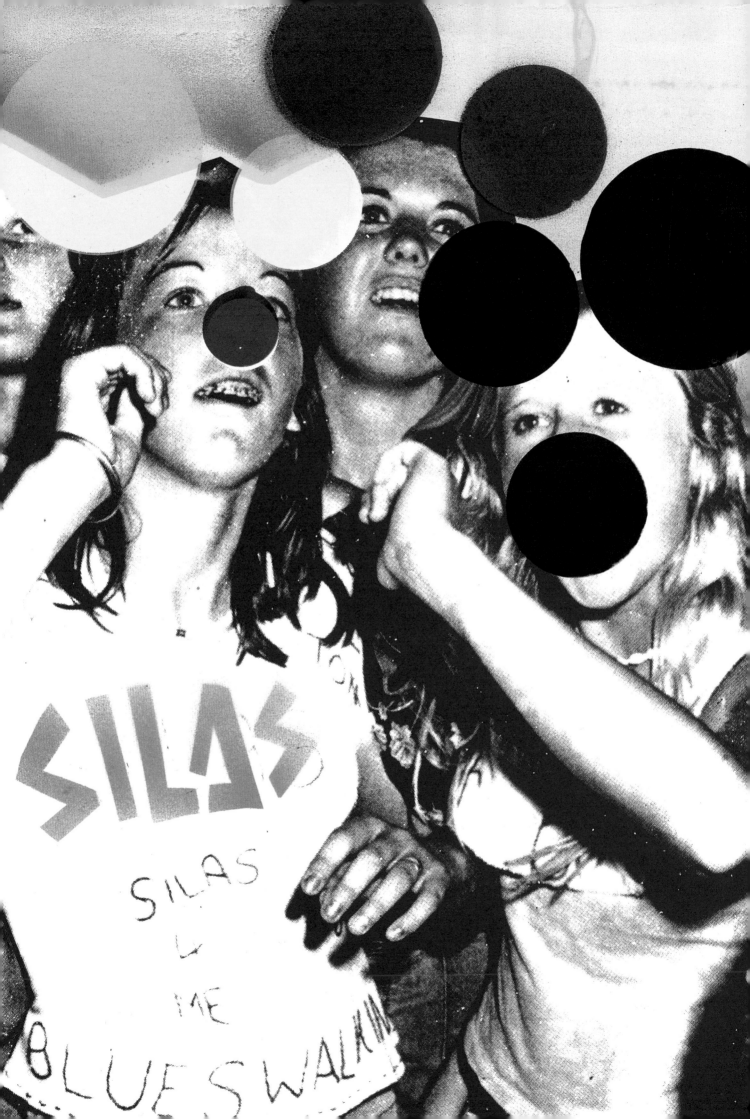

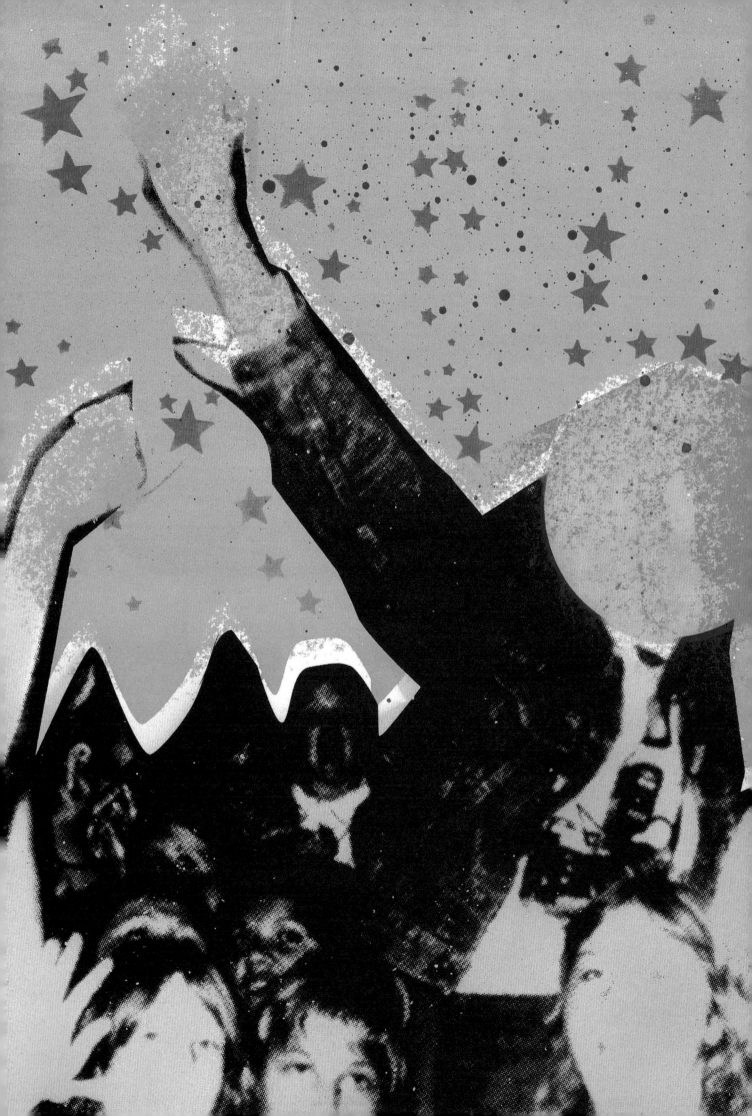

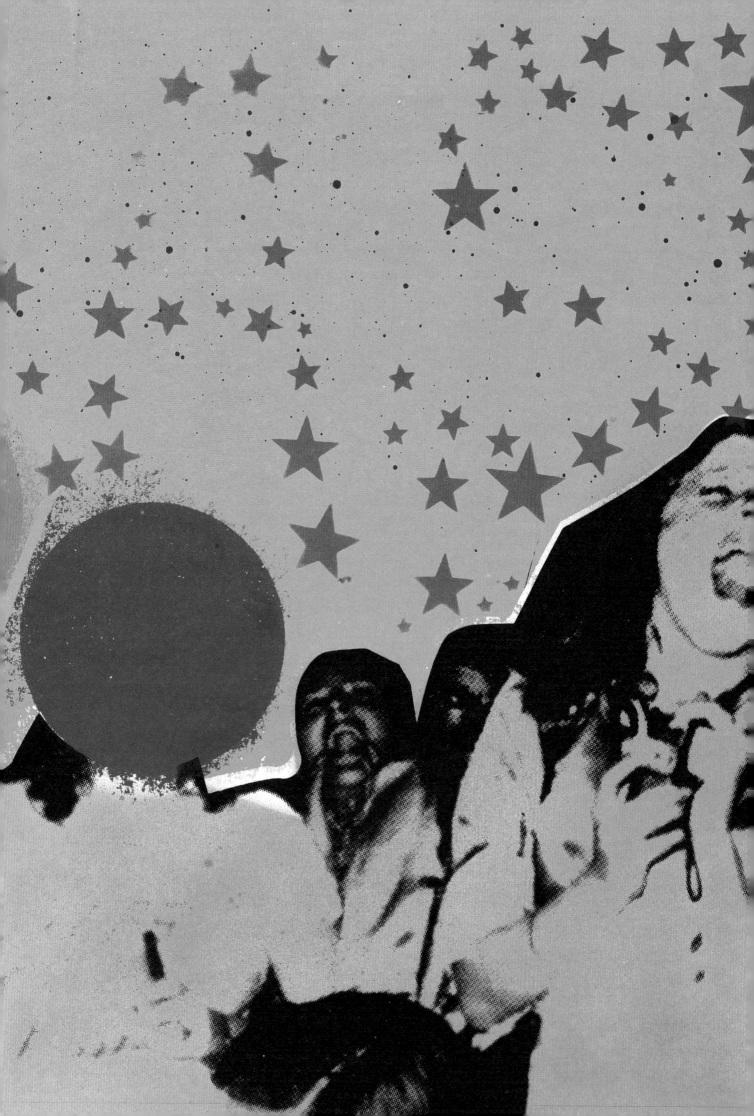

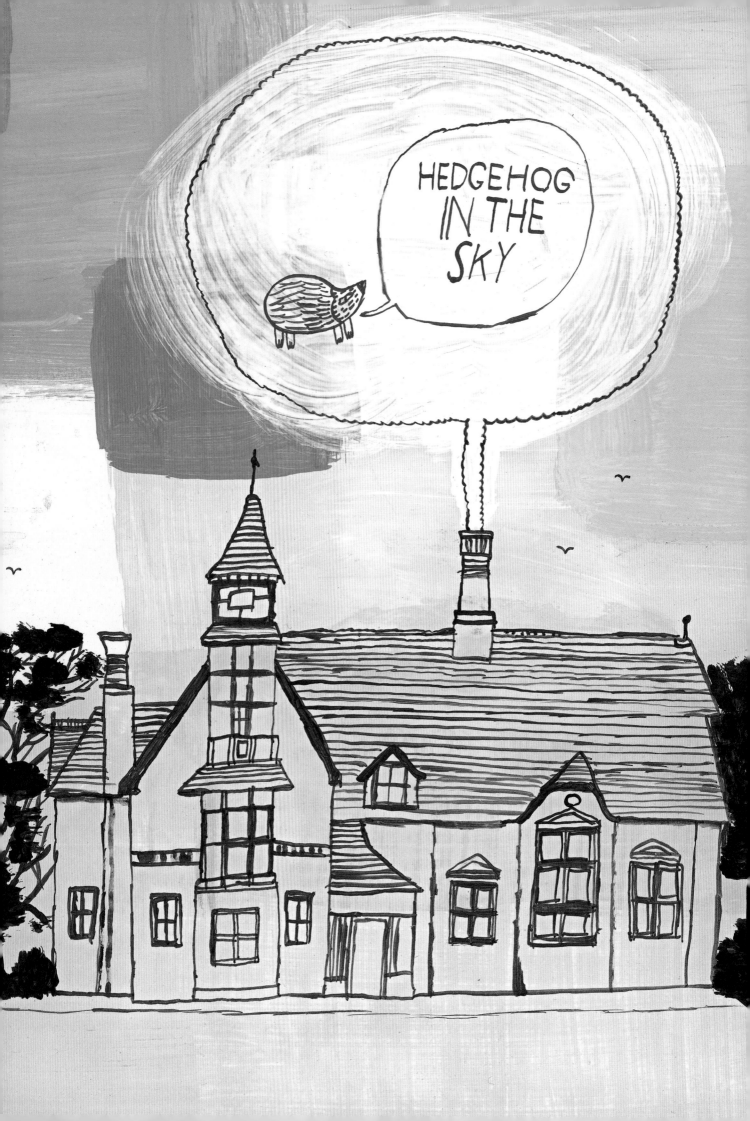

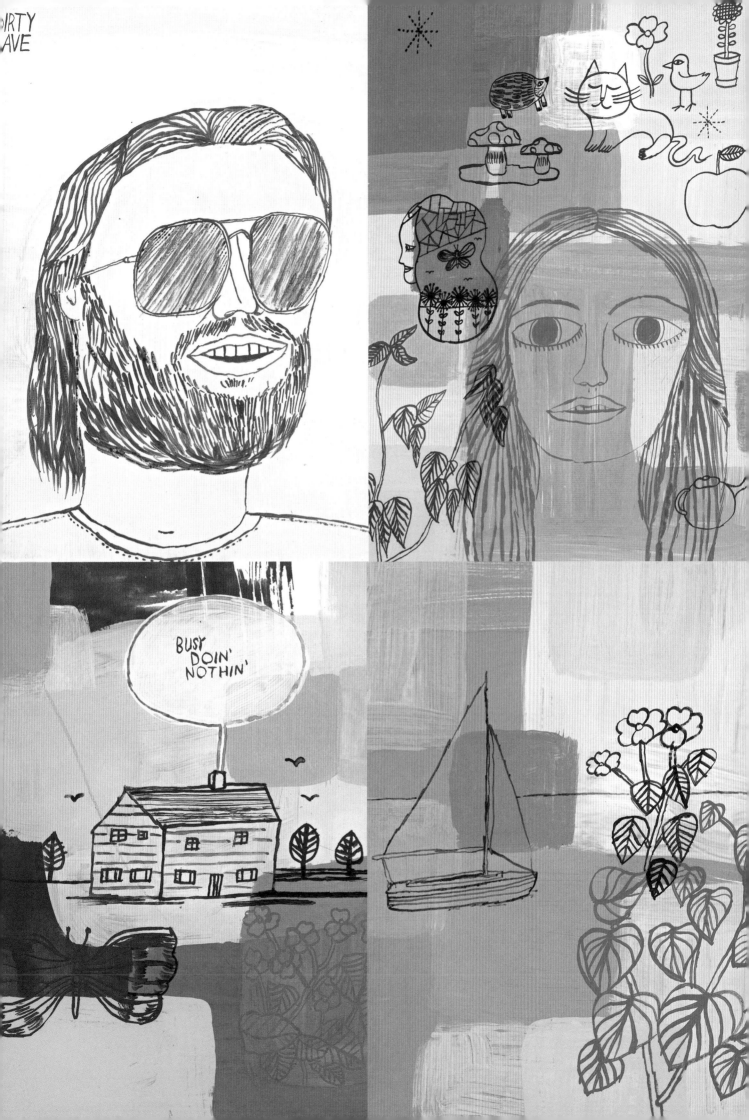

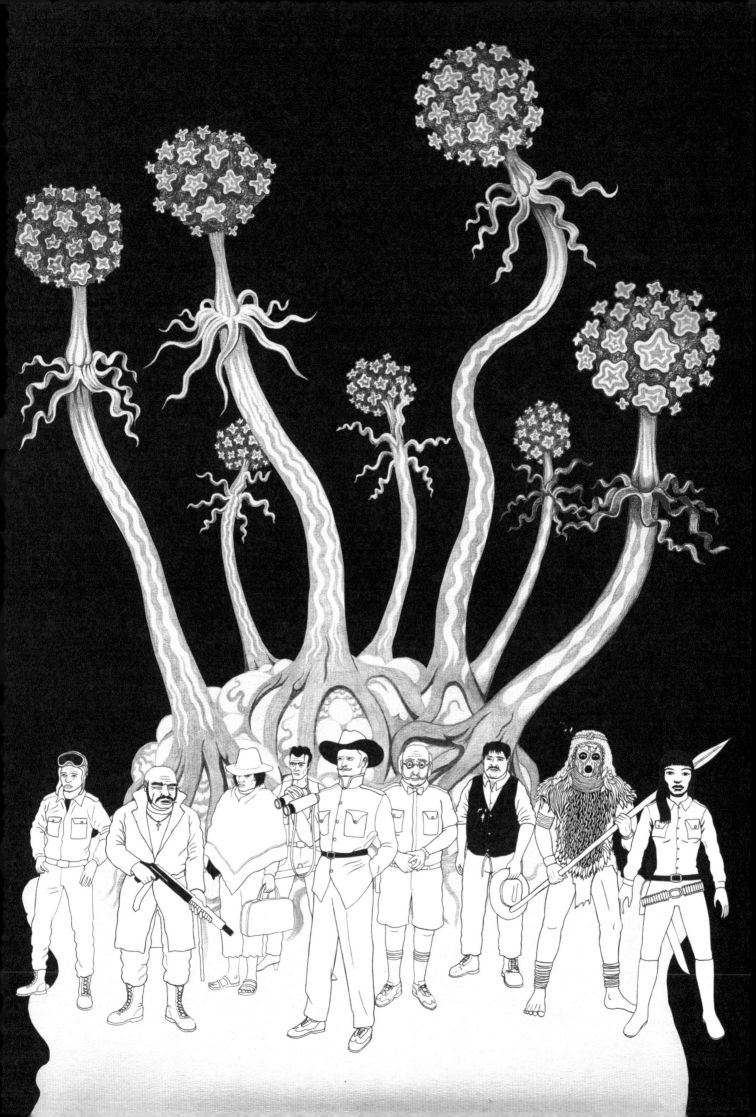

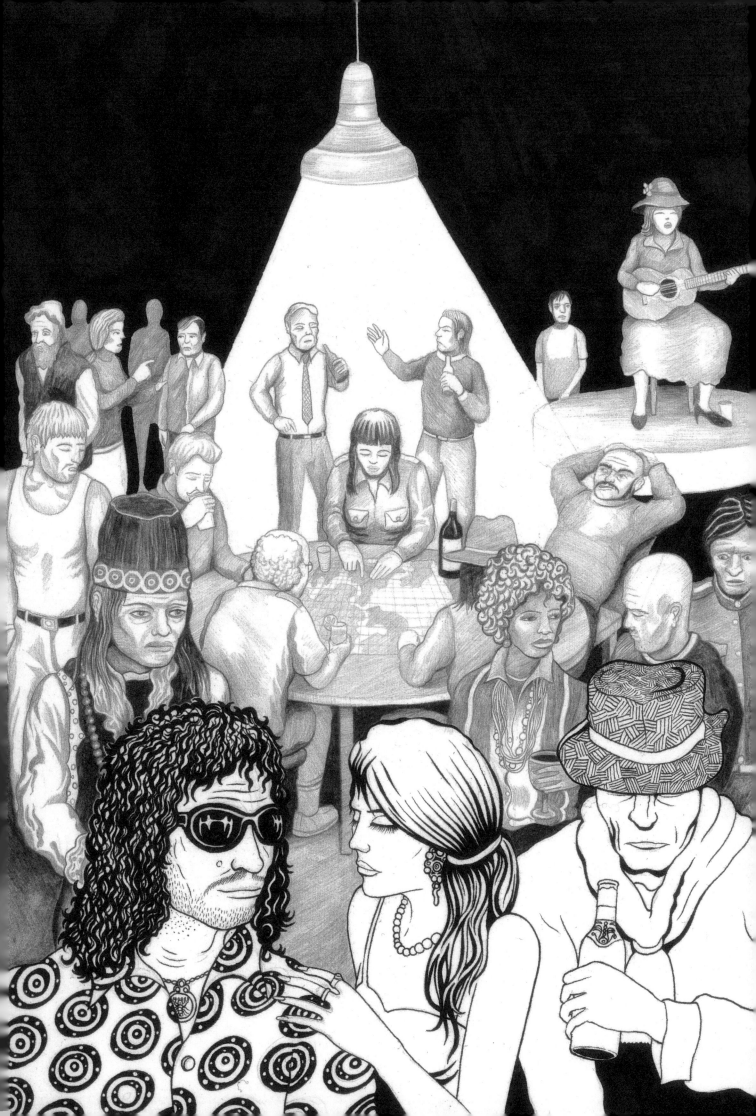

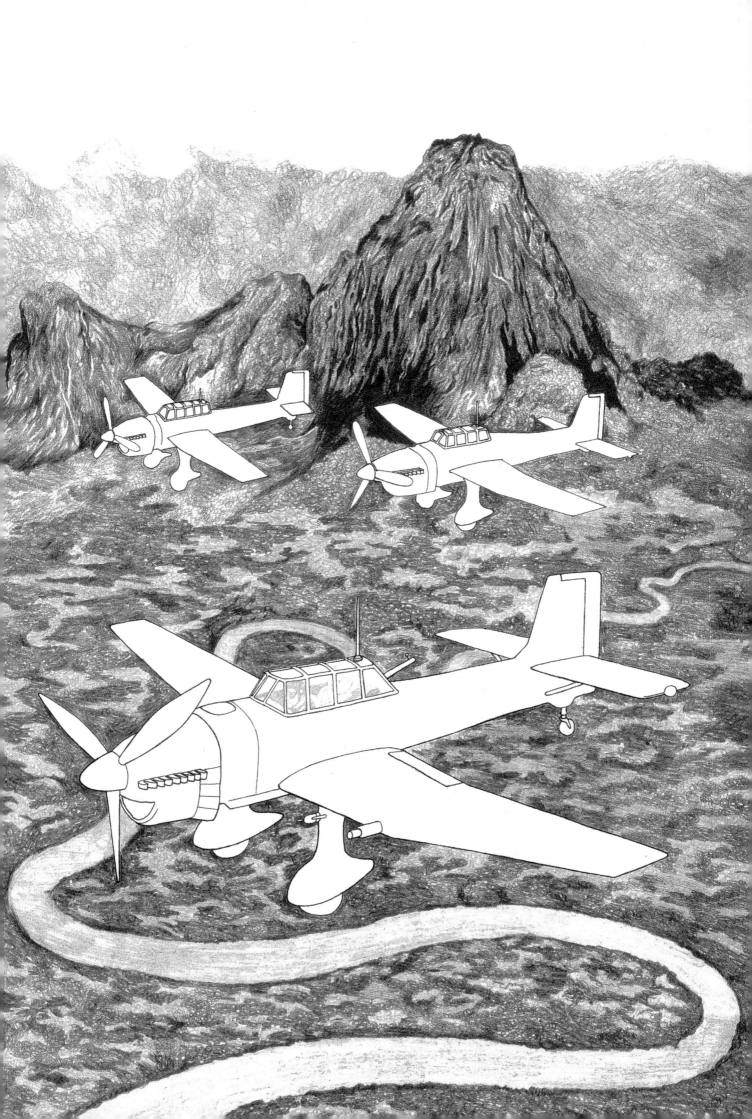

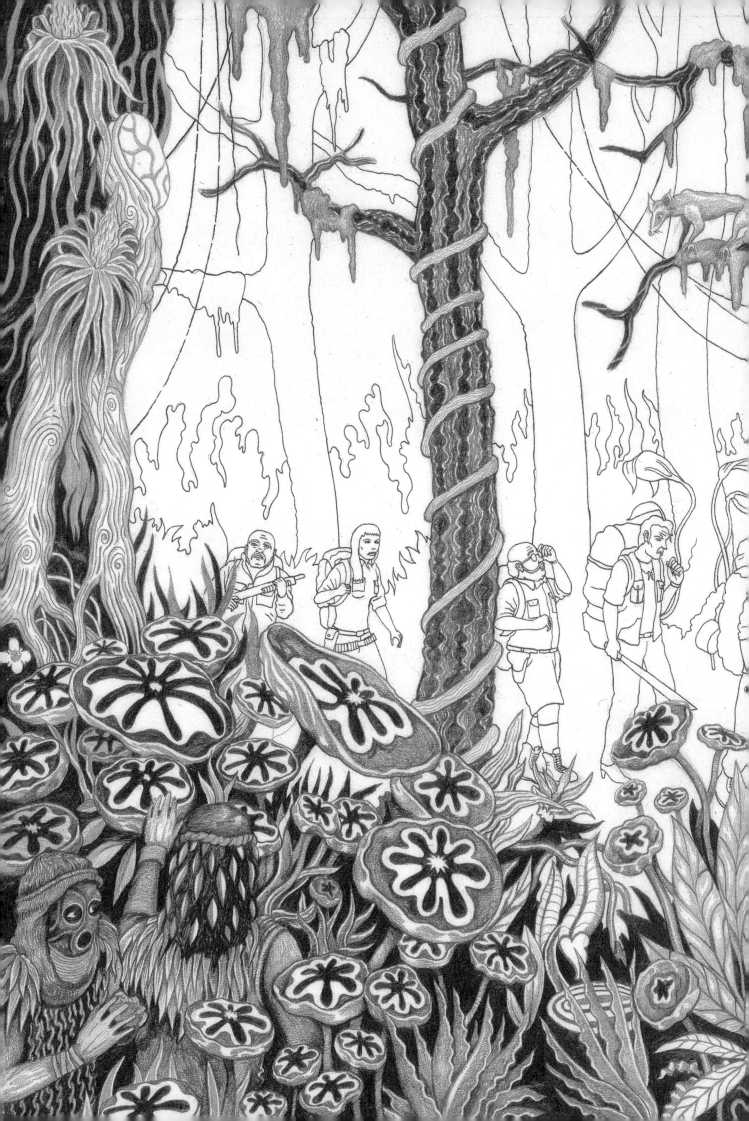

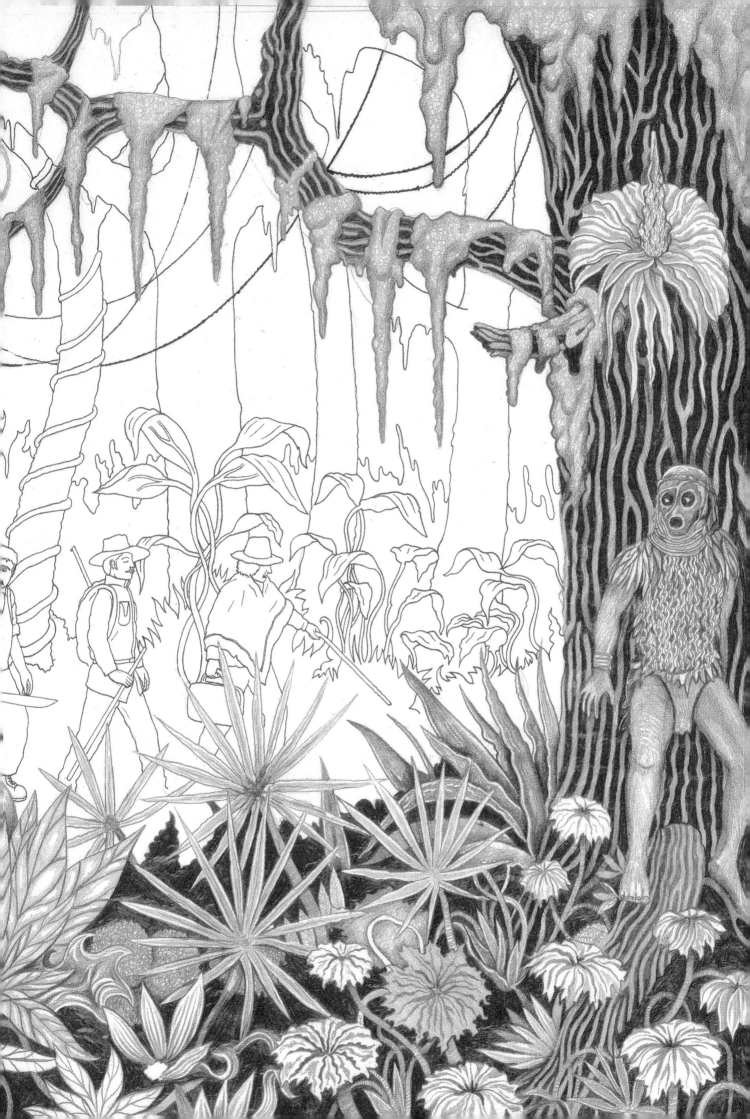

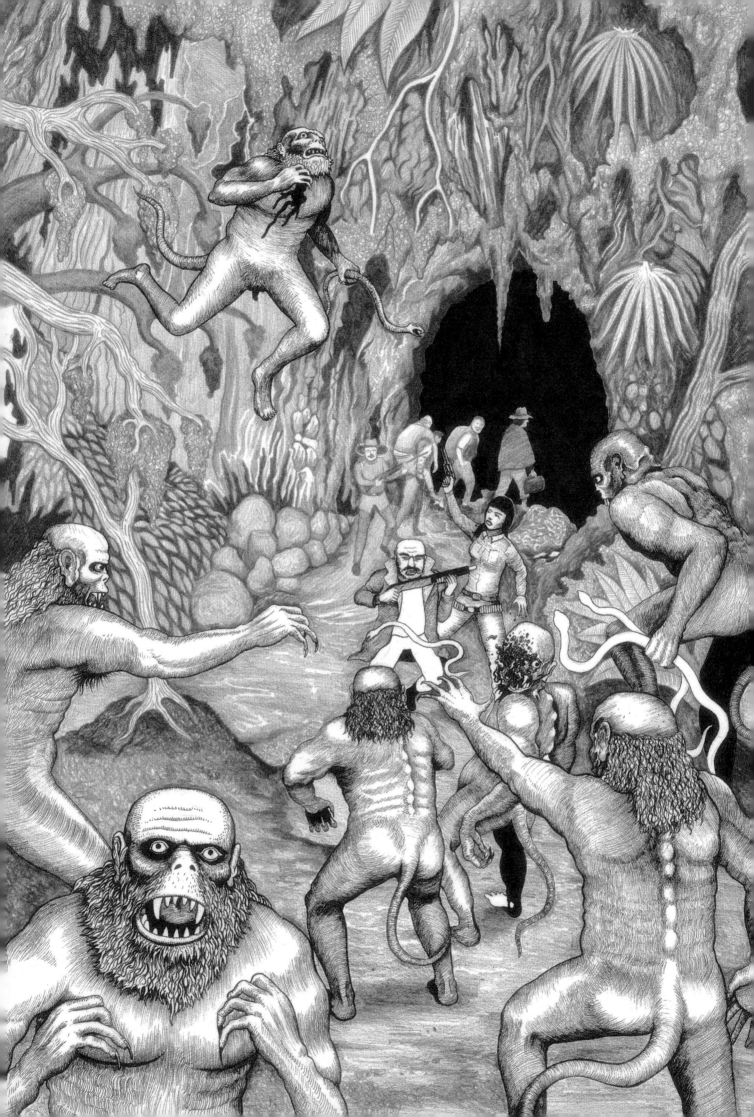

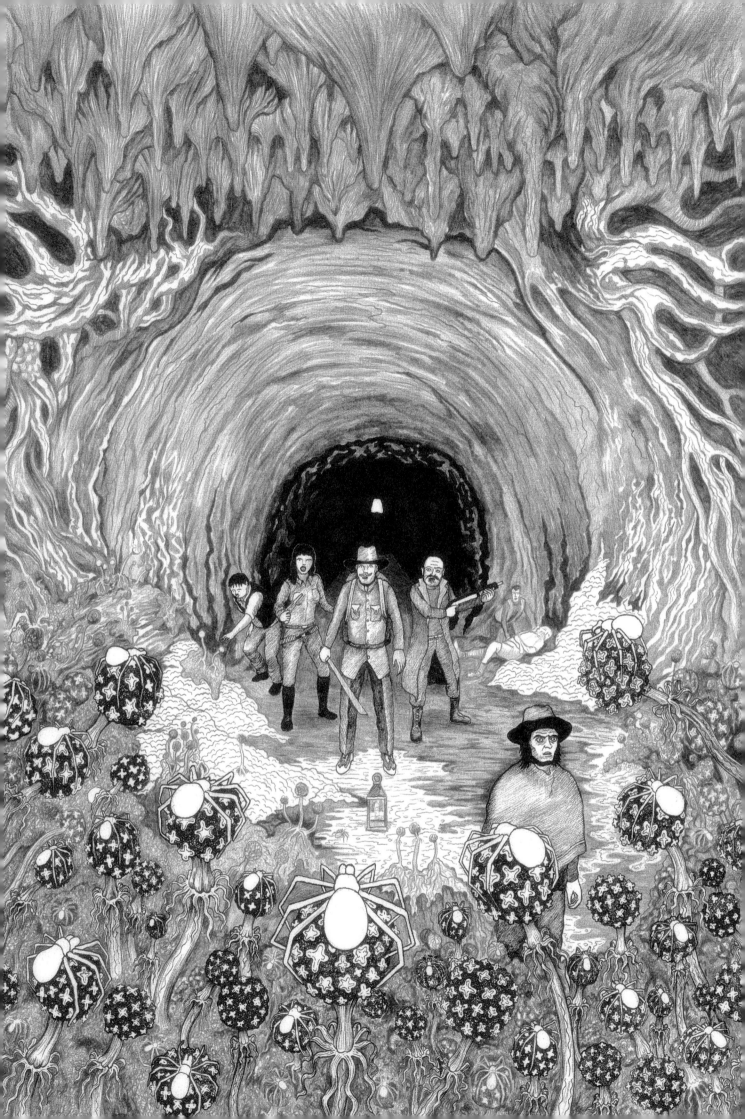

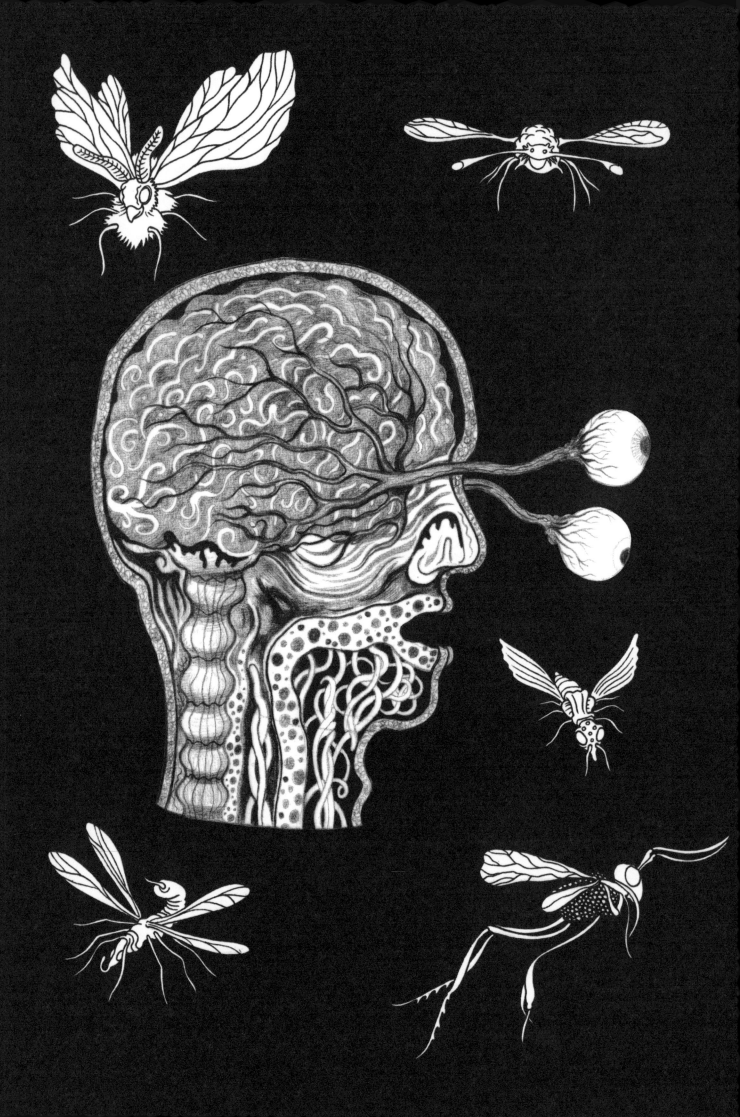

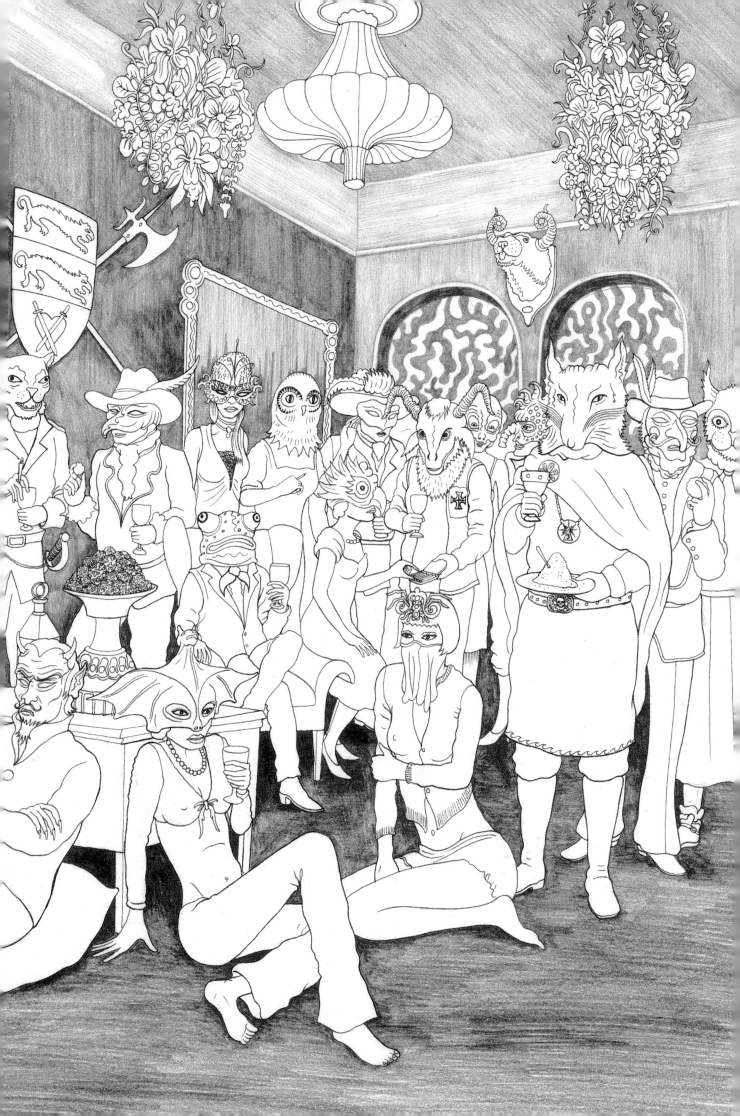

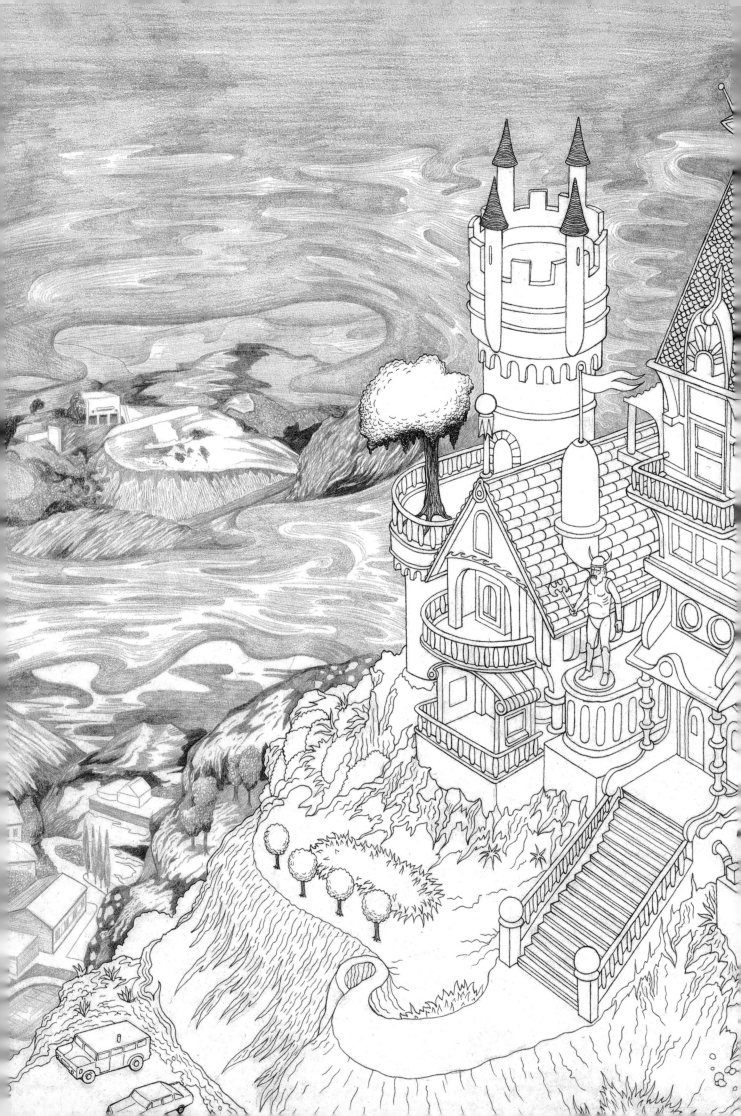

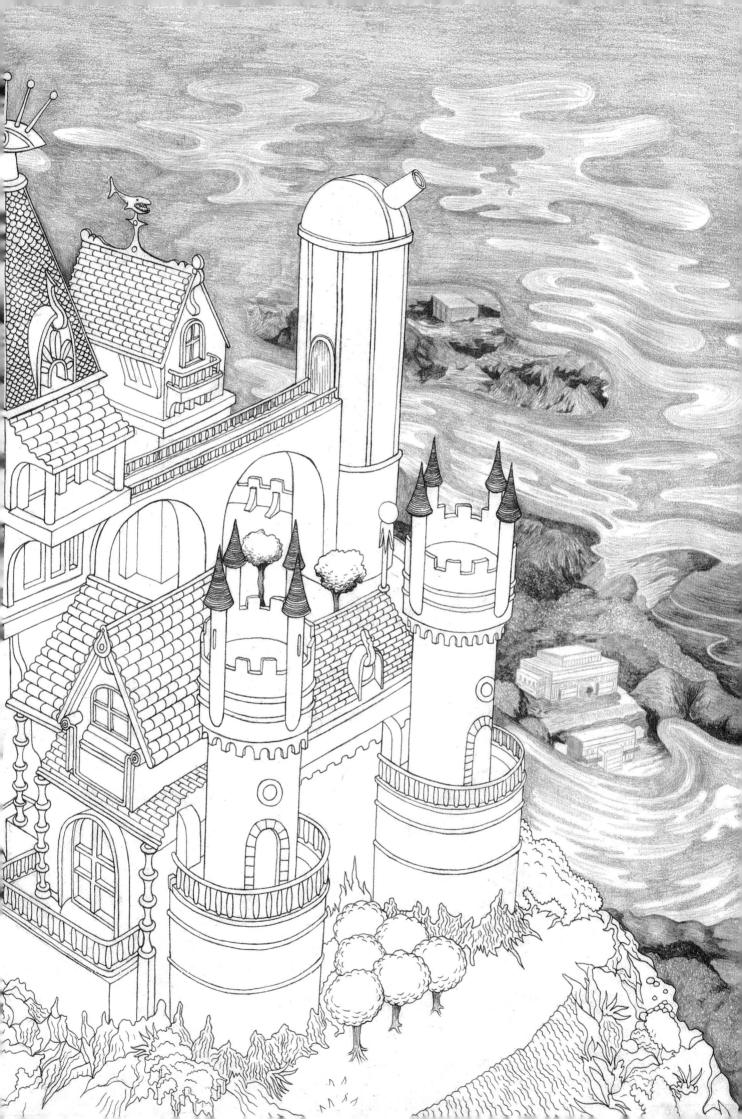

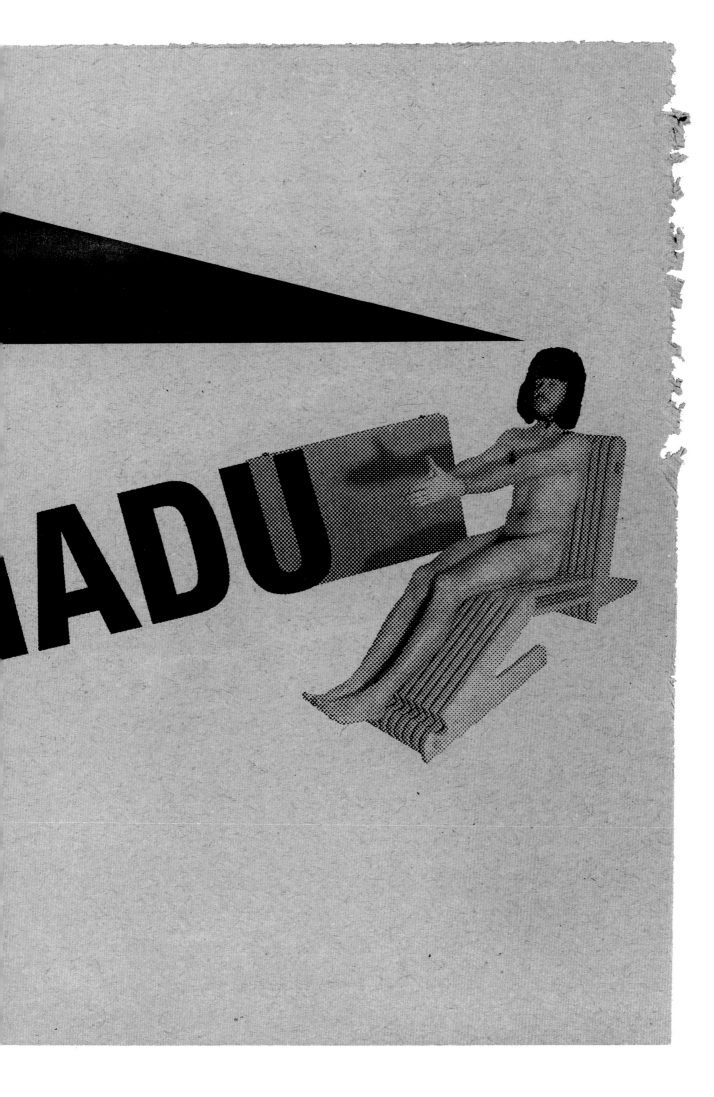

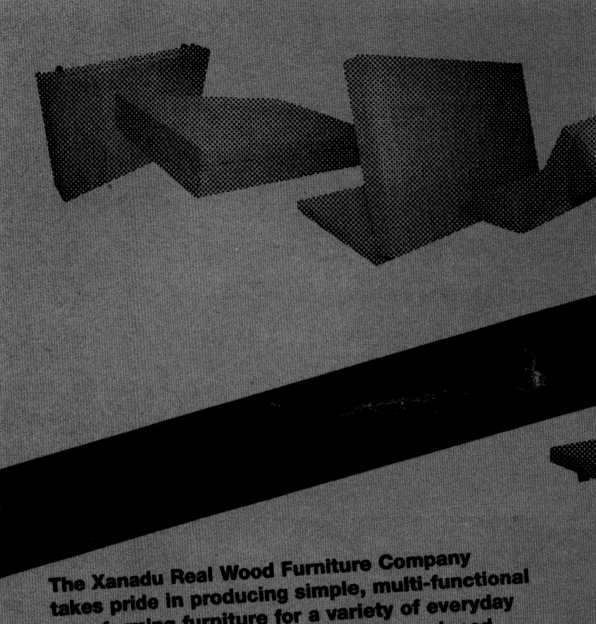

The Xanadu Real Wood Furniture Company takes pride in producing simple, multi-functional transforming furniture for a variety of everyday use. Our cutting edge designs are produced with you in mind. We feel that you deserve the best that nature offers and it is our job to make sure that you get it.

XANADU

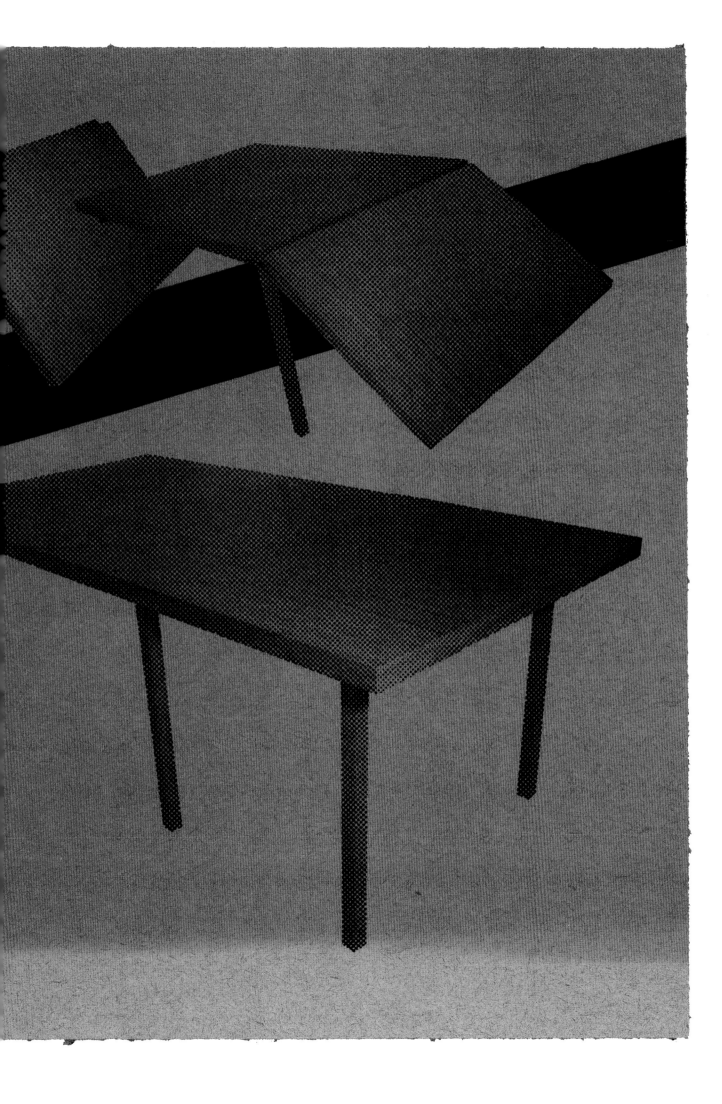

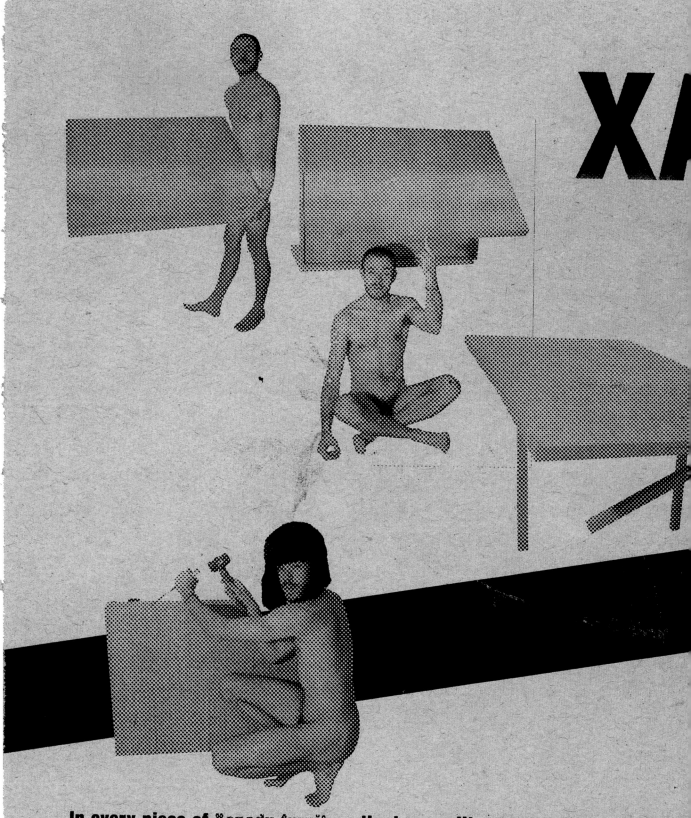

In every piece of Xanadu furniture the top quality construction compliment[s]
impeccable choice of materials. We do not hide our wood behind cheap p[aint]
stains. At the Xanadu Real Wood Furniture Company we believe everythin[g]
should be enjoyed just as nature intended.

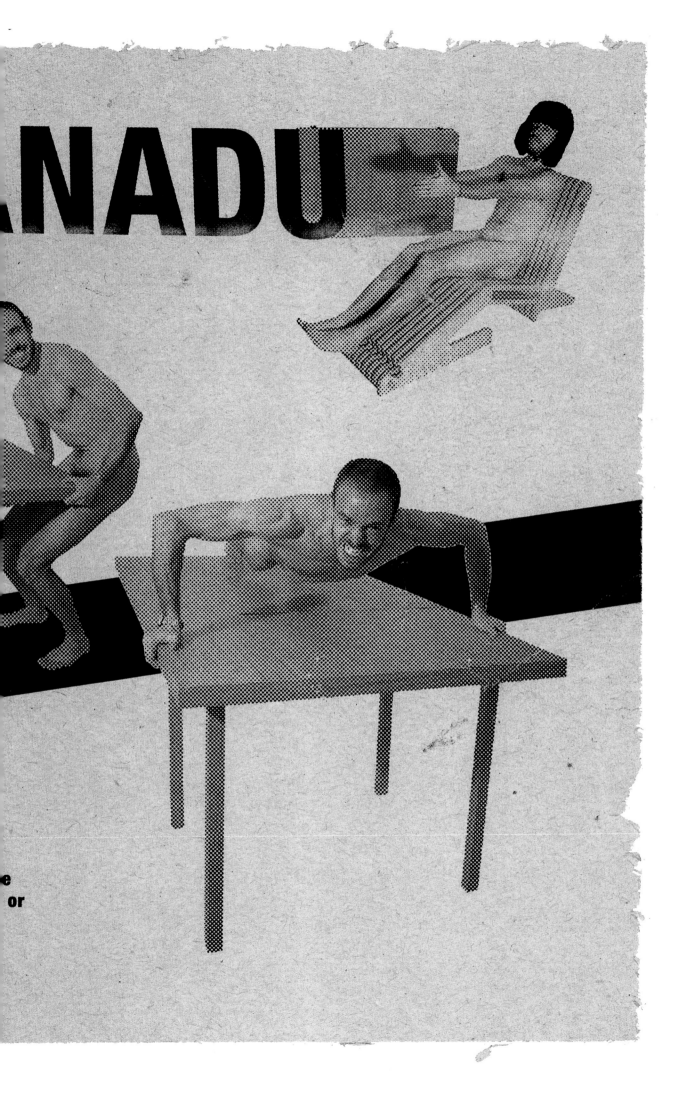

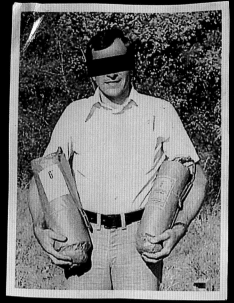

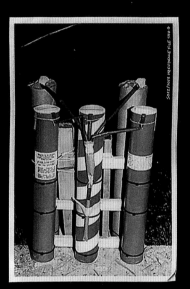

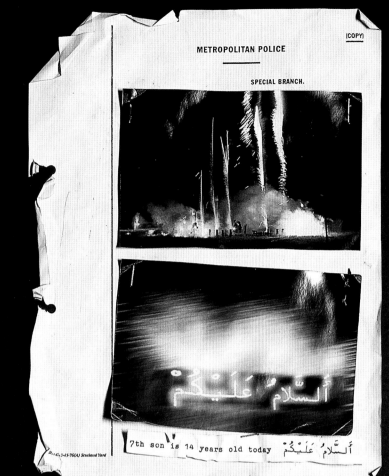

ٱلسَّلَامُ عَلَيْكُمْ

7th son is 14 years old today   ٱلسَّلَامُ عَلَيْكُمْ

# MYSTERY ATTACK!

### South East News Desk

MASSIVE EXPLOSIONS lit up the skies over Kent and parts of Sussex this morning, but no-one seems to know exactly what they were or where they came from.

Pandemonium broke out when residents of the two counties were awoken at around 1 AM this morning by the sound of a violent eruption.

Fearing they were under attack, people ran out into the street to be greeted by the sight of a plume of fire and smoke rising nearly half a mile into the early morning sky.

Twenty minutes later, as panicking residents poured from their homes, there followed another thunderous bang which sent a second pillar of fire skyward to join the other under the bright half-moon.

As the volcanic columns floated across the starlit heavens, debris rained down on the streets, from Pluckley to Rye, Ilcombe to Orpington.

Many villagers and townspeople were overcome as a pall of soot and dust covered an area of over twenty square miles.

Kent's telephone exchanges had their switchboards jammed when operators were inundated with 999 calls requesting help from the police, ambulance and fire services.

But in Ashford people tell a different story. Many witnesses say they saw smaller explosions and oven fireworks, some believing they emanated from a nearby field owned by the M.O.D.

Ex-serviceman Mr. Arthur Fletcher, who served as a Sapper during the Suez Campaign, told our reporter, "The pyrotechnics incorporated a signalling device which was commu messages in wh nised to buy A had my specs on have been able to pher it."

Another eyewit ness described scene, "It was all ve peculiar. At first thought the Third W War had broken ou that the Provis were attacking t M.O.D. But subseque ly, after the dust had sot tled, people proceeded to bring out chairs and stereograms, make each other cups of tea, break open the homebrew and generally have a high old time watching the skies. Actually, it was rather more enjoyable than the Coronation.

At 4 AM this morning the explosions ceased, and people returned to their houses, leaving the streets outside covered by a thin film of soot, not to mention beer slops, spilt tea and sandwich crusts.

As Kent County Council prepare for the inevitable clean-up, the mystery continues to remain unsolved; no spokesmen were available for comment at either the Ministry of Defence, Kent Constabulary or the Home Office.

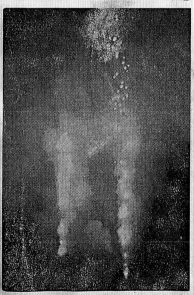

INFERNO... The sky above Kent lights up

## BRITAIN'S BIGGEST D

# 'IRA' MAN SILAS FLEES JAIL

### By DAVID NICHOLS

OFFICERS of Kent Constabulary were today issuing warnings to the population of Maidstone and surrounding areas after a man escaped from the local prison last night.

A warder was knocked unconscious before the fugitive scaled the walls and escaped on a motorbike after a disturbance erupted during 'lights out' at 9·30 PM yesterday evening.

MAIDSTONE: 'Unbreachable'

The prisoner, Silas Holmes, was being held on remand while awaiting trail for hijack and theft. Special Branch, investigating the possibility of Holmes being a member of the Provisional Irish Republican Army, had also applied for Holmes to be transported to the Maze Prison, Ulster, under the new Internment Law introduced last month.

But this morning, a spokesman for Sinn Fein phoned the Reuters news agency denying Holmes had any association with the IRA, adding "Our only knowledge of Holmes is his plight, which is another example of an innocent man facing British injustice due to the draconian introduction of Internment."

### Greasers

Escapee Holmes, 29, is believed to be armed and dangerous and has, according to Kent Police, "possibly contacted local greaser or rocker gangs to aid him in evading the authorities."

Meanwhile, a Prison Service enquiry into security arrangements at Maidstone, previously said to be 'unbreachable', is due to begin next week.

## WANTED INTERNATIONAL CRIMINAL

### HOLMES, SILAS

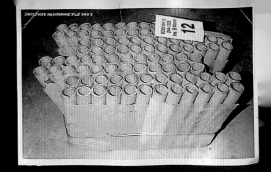

| Sender | Sender's reference number | Date |
|---|---|---|
| U.S. Department of Justice Washington, DC 20530 | U.S.D.O.J.71-170 | 8/27/71 |

| Addressee (quote reference number if any) | ( ) ICPO-INTERPOL GS | ( ) NCB of: |
|---|---|---|
| G.S.71-170 US/GB/I/HELV | General Secretariat | (country) Lyon, 06 France |

CAUTION: This person is considered to be (explain in item 21):
(X) Mentally ill    (X) Armed    (X) Infectious    ( ) Suicidal
(X) Addicted to drugs  (X) Violent    (X) Other

| 1. | PRESENT FAMILY NAME (1) | Holmes |
|---|---|---|
| 2. | FAMILY NAME AT BIRTH/PREVIOUS FAMILY NAME(S) (1) • | Holmes |
| 3. | FORENAME(S)/GIVEN NAME(S) (1) | Silas |
| 4. | SEX | (X) Male    ( ) Female |
| 5. | DATE OF BIRTH (day, month in full, year) | c. 29 yrs (not confirmed) |
| 6. | PLACE OF BIRTH (town, country) | Damascus, Syria. (n. conf. - see supplement) |
| 7. | FATHER'S FAMILY NAME AND FORENAME(S)/GIVEN NAME(S) | Holmes, M. (see suplmnt.) |
| 8. | MOTHER'S MAIDEN NAME AND FORENAME(S)/GIVEN NAME(S) | (n. conf. - see suplmnt.) |
| 9. | RESULT OF IDENTITY CHECK | ( ) Identity confirmed    (X) Identity not confirmed |
| 10. | NATIONALITY | US citizen (n. conf. - see suplmnt.) |
| 11. | RESULT OF NATIONALITY CHECK | ( ) Nationality confirmed    (X) Nationality not confirmed |

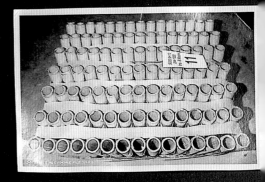

| 12. | DESCRIPTION (as full as possible) | HEIGHT: 6' 2-5"   BUILD/WEIGHT: 175-200 pounds   HAIR: Long, bearded   EYES: Gray/brown |
|---|---|---|
| | DISTINGUISHING MARKS (scars, tattoos, deformities, amputations, spectacles, etc.) | 2" scar on left cheek  Tattoos on arms/back/legs/chest/neck  Wears tinted spectacles |
| 13. | CHARACTERISTICS (bearing, gait, speech, mannerisms, habits, etc.) | Slow gait when walking  Speech - fast, deep register  Smokes pipe |

14. ADDITIONAL INFORMATION: (e.g. any previous criminal activity, etc.)
Communist Party (U.S.C.P.) Membership N.Y.C. 1967- Arrested N.Y.C. U.S. 9-11-68 Substnce. pos., State dis. Sodomy; chg. dismissed; Astd. LDN, G.B. 1-1-70 Conspiracy; chg.dis. Manager business (Bookmaker) owned by kn. membrs. of terror gp. —IRA Fled LDN 2-70: Astd. BRINDISI, IT. Arson - cafe owned by kn. membrs. Fatah org.9-70; bailed by ████████, Egyptn. businessmn. (s. sup.)chg. dismissed: Targeted by Brigate Rosse 10-70 (s. exhbt. 3) Employed pilot for Mayor ██████ (Susp. 1.A.) 11-70: Blievd. 3 million, f. (Swiss) invested in ████████ Aquisitions Corp. U.S. Governor ██'s son ██████ (s. sup.) heir (Saudi) on Co. board (-crnt. inv. Intpol. Switz.).

(1) If the names given under Items 1 and 2 are used with dates and/or places differing from those given under Items 5 and 6, please supply details.

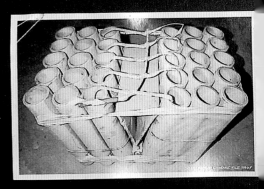

---

## DECODED COPY

☐ AIRGRAM    ☐ CABLEGRAM    ☒ RADIO    ☐ TELETYPE

URGENT 9-10-71
TO DIRECTOR
FROM SAC N.Y.C. 282039

RE: SUSPECT 1.A., SILAS HOLMES, CAMORRA CRIME INC.,
NARCOTICS, ARMAMENTS; SOUTH ITALY
    POLIZIA DI ITALIA - SURV. TEAM RPTD. HOLMES' BEHAVIOR
"GROWING INCREASINGLY ERRATIC, WILL COMMIT MISDEMEANOR WITHIN
DAYS." 9-7-71, 9-8-71 POLIZIA DI ITALIA - SURV. TEAM RPTD.
HOLMES DISAPPEARED: SUSP 1.A. MADE STATEMENT TO CARABINIERI -
CIVIC AIRPLANE STOLEN LAURO, CAMPANIA, AIRFIELD. 1.A. ACCSD.
HOLMES OF THE THEFT. PLANE DESCR. S/E TURBO PROP. CESSNA 153
W. CIVIC COAT OF ARMS LIVERY ON TAIL FIN/WINGS: H.M. CUSTOMS
AND EXCISE RPTD. TO S013 G.B.. AIR TRAFFIC CONTROL INF. THEM
OF SIMILAR LIGHT ARCRFT. IN AIRSPACE ABVE. KENT CNTY. AIRPLANE
DITCHED FIELD NR. TOWN OF DOVER, G.B.. PLANE FITTED DESCRPTN.
BY SUSP. 1.A.. LOCAL POLICE AT SCENE ARRSTD. PILOT. GAVE NAME
AS SILAS HOLMES & REQSTD. POLICE PROTECTION. SPECIAL BRANCH
S013 SRCH. AIRPLANE FOUND LGE. CARGO OF EXPLOSIVE MATERIALS.
S013 CURRENTLY INTERROGATING SUSPECT [HOLMES].
    COMMENCING INITIAL EXTRADITION PROCEEDURE PENDING
AUTHORIZATION; AWAITING OTHER INSTRUCTIONS
    LETTERHEAD MEMO FOLLOWS.

RECEIVED:        5:05 PM       J.W.D.

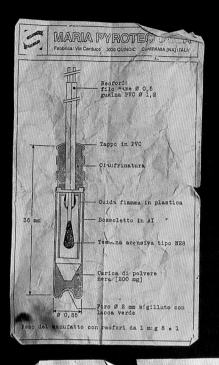

9-11-71

واشنطن في ٧ نيسان

Dear Luca,

Apologies are not neccessary. My brother has not been the same since our father died, so it's not the only thing that caused the sickness.

Your offer to pay for his treatment is kind, but again not neccessary. The doctors say he is doing very well and he will be going home soon to study under a religious teacher, which will do him good.

My new business with the Texan is good, he's got alot of influence here, so it has been easy.

Lastly, I want the cunt Holmes dead as soon as possible, and when he is I want his cock and balls sent to my brother.

Sorry for writing to you in English, but my Italian is as good as your Arabic.

Yours

محمد

Mohammed

**UNITED STATES GOVERNMENT**

# Memorandum

TO : SAC, WASHINGTON, D.C. (62-5154)        DATE: 3/1/71

FROM : ACTING SAC, INTERNAL AFFAIRS (62-7586)(SQ3)(P)

SUBJECT: DOMESTIC/INTERNATIONAL INTELLIGENCE COOPERATION (CIA/FBI)

    ANSWER TO FBI QUERY - HOLMES, M., FATHER OF HOLMES, SILAS?

    RE BACKGROUND/IDENTITY CHECK: HOLMES, M.: I.D. CONFIRMED
    BY THE AGENCY.

    HOLMES, M.: HIGHLY VALUED (EX-)OPERATIVE - RETIRED
    (INCOGNITO) - IS FATHER OF SUSPECT HOLMES, S.

    EXTRACT FROM 1948 CIA REPORT - THE UNITED STATES OF
    AMERICA'S POSITION ON THE AL MARYAMM SCROLLS - ATTACHED

    SEND TO HOOVER?
    PLEASE CONFIRM.

    SAC (62-7586)(SQ3)(P).

1687          S8B

I was approached by XXXXXXXX XX XXXX an Egyptian merchant
with an ancient looking and disintegrating scroll. I agreed
to photograph it with a view to finding someone who could
identify it.

The scroll was unrolled on the roof of the American Legation
and photographed. Thirty frames were taken, which was not
enough to cover the entire scroll.

The "Hamzim" (the seasonal desert wind) was very strong that
day. Gusts blew away large chucks of the scroll. A
Bedu guard later recovered some.

I fear much is lost forever.

XXXX XXXXXXX, U.S. Embassy Linguist, in Beirut was shown
the photographs. XXXXXXX identified them as part of the Old
Testament, mostly the Book of Daniel, written in Aramaic and
partly in Hebrew. But he also observed that some passages
contain parables attributed to Christ in the Gospels, adding
that the historical details in the annotations and footnotes
suggest the writings predate the Christian Era by some
120-150 years. Obviously, this has profound implications.

Because the public already has knowledge of the discovery,
I feel that obfuscation of the exact nature of the writings
must now be our aim.

Firstly, I suggest we claim that any photographs were lost
in transit.

Secondly, I am liasing with the Vatican's representatives,
the Dominican Friars of Jerusalem, offering them custodian-
ship of the scroll. Their Seminary is a highly respected
academic institution and as envoys of the Roman Church, they
have voiced the Vatican's concern over the discovery &
ramifications (within the forum of Opus Deii - see September
Israel/Palestine Int. Rpt. Annex 7.d.)

Thirdly, I shall ensure that there will be no further word
from XXXXXXXX XX XXXX (the Egyptian)

I await further instructions.

    M. HOLMES, CIA ATTACHÉ, DAMASCUS, OCTOBER 27, 1948.

CIA HISTORICAL REVIEW PROGRAM
RELEASE AS SANITIZED

14

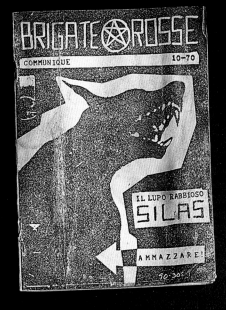

---

3.5. No.1 (Flimsy)        **METROPOLITAN POLICE**        (COPY)

Special Report }

        **SPECIAL BRANCH.**

    15th  day of  March,    1971.

SUBJECT
Second
Report on
Suspect 1.A.,
IRA,
Silas Holmes &
arms/narcotics.

Reference to Papers
FBI (AC20-9-7)
SO13/18/24/71
FDPI (I200-70)
INT (9-11-01)

    This report, concerning Suspect 1.A., the Irish
Republican Army, Silas Holmes and the trade in arms and
narcotics is submitted for the information of the
Director of Public Prosecutions; Interpol (including the
US Federal Bureau of Investigation and Forza di Polizia
Italia); and the Home Office.

    On Saturday 1st March, a meeting was held in two
sessions at the Tote Turf Accountants, 37 Prince of
Wales Road, London N.W.1, between four known members
of the Provisional IRA (see. surveillance minutes 3/71-
13B7) and an Italian gentleman later identified as
Suspect 1.A., Mayor of XXXXXX, Campania, Italy.

    The first session was held between 11.30 a.m. and
1.12 p.m.. A discussion concerning a consignment of
Nitro Glycerine rods from Suspect 1.A. developed into an
argument because 1.A. "... promised (them) to (his) dear
friend - he pass on recently (?) - his son - the boy (?)
must (honour a construction contract) with Faisal in
Saudi - (a) big important one." (13B7-12.12 p.m.)

    Subject 1.A. then offered "30 kilo brown" at
a "discount(ed)" rate of "15(?)" to be delivered
"personal(ly)" by (our) good friend Silas." (13B7-12.23
p.m.). For reasons of decency, the men's reactions
will not be reported here (refer to 13B7-12.23/4 p.m.).
The proceedings then continued in a more orderly and
dignified manner.

Page 1.
(of 128)

SO13-G13-45-76(A) Scotland Yard

UNITED STATES DEPARTMENT OF JUSTICE

FEDERAL BUREAU OF INVESTIGATION

WASHINGTON, D.C. 20535

In Reply, Please Refer to
File No.

JANUARY 12, 1971

RE: SUSPECT SILAS HOLMES / HELL'S ANGELS INC.

ATTACHED PHOTOSTATS FROM PREVIOUS FILES

(1968 Hellsang E.C. 27/12 - 28/14): A. REINER, D.C.

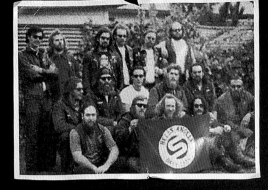

SILAS HOLMES of the "Galloping Gooses" advised members of the press that 140 gallons of beer and 100 gallons of wine would be consumed along with the 400 pounds of burro meat which was barbequed.

Deputies said the riot broke out when the motorcyclists, many shaggy-haired and bearded and jacketed in the 'Hell's Angeles' style, began molesting women at the resort. Some cut the pigtails off girls and waved them in the air.

Nine motorcyclists were booked in county jail. ████ were charged with disorderly conduct by Issaquah District Justice Court Judge ████████ bail at $50 apiece.

SILAS HOLMES, 29, of 417 Eastlake Ave. E. of the "love-in". He was placed under a police 'hold' order.

NOTE: Records of Holmes are o████████ "Hell's Angels" is a motorcycle club with a membership of about 1,000. They have a reputation as troublemakers and have been publicized as instigators of riots. Some of this group have been classified as homosexual and as narcotic users. (62-110359)

John Edgar Hoover
Director

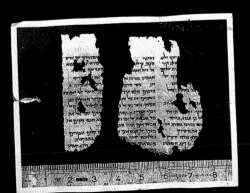

The enclosed picture, which appeared in today's Evening Star, merits your attention. HOLMES, back row 3rd left.

**CENTRAL INTELLIGENCE AGENCY**
WASHINGTON. D.C. 20505

DEC 29 1971

Mr. John Edgar Hoover
Federal Bureau of Investigation
Washington, D.C.

Dear Mr. Hoover

    After having carefully assessed the situation
regarding Silas Holmes, the Agency kindly requests that
the Bureau cease and desist in its investigation.

    We have come to the conclusion that any publicity
about a resulting trial would bring certain facts and
events to the attention of friends abroad and the
general public alike, and publicizing such information
is not, at present, of benefit to the interests of the
United States.

    We would also like to inform you that the President
is in accordance with this view.

    We trust that any information provided by the Agency
was of assistance.

                              Sincerely

                              Charles E. Savige

                          Charles E. Savige
            Acting Information and Privacy Coordinator

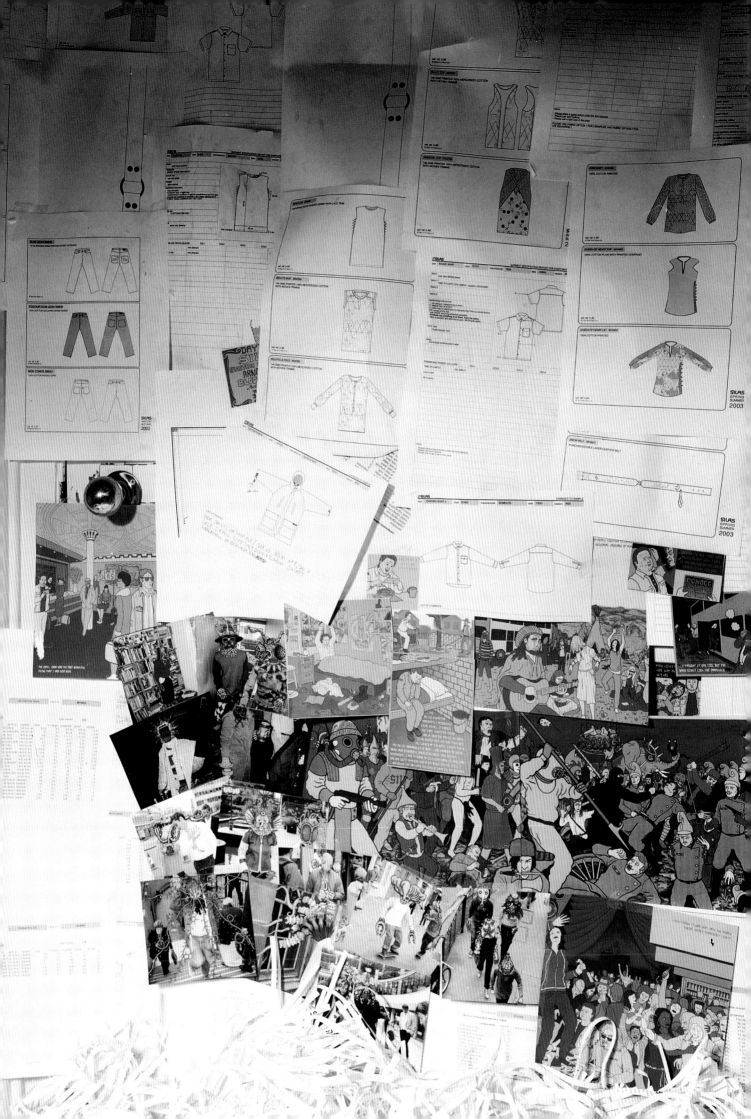

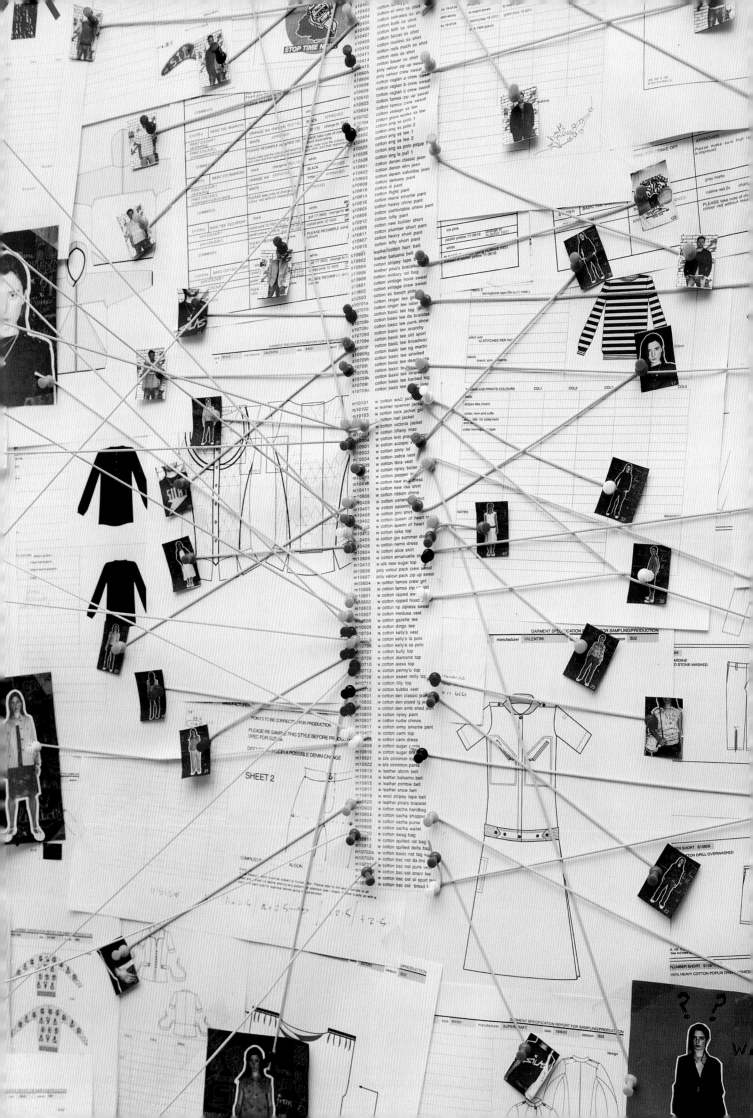

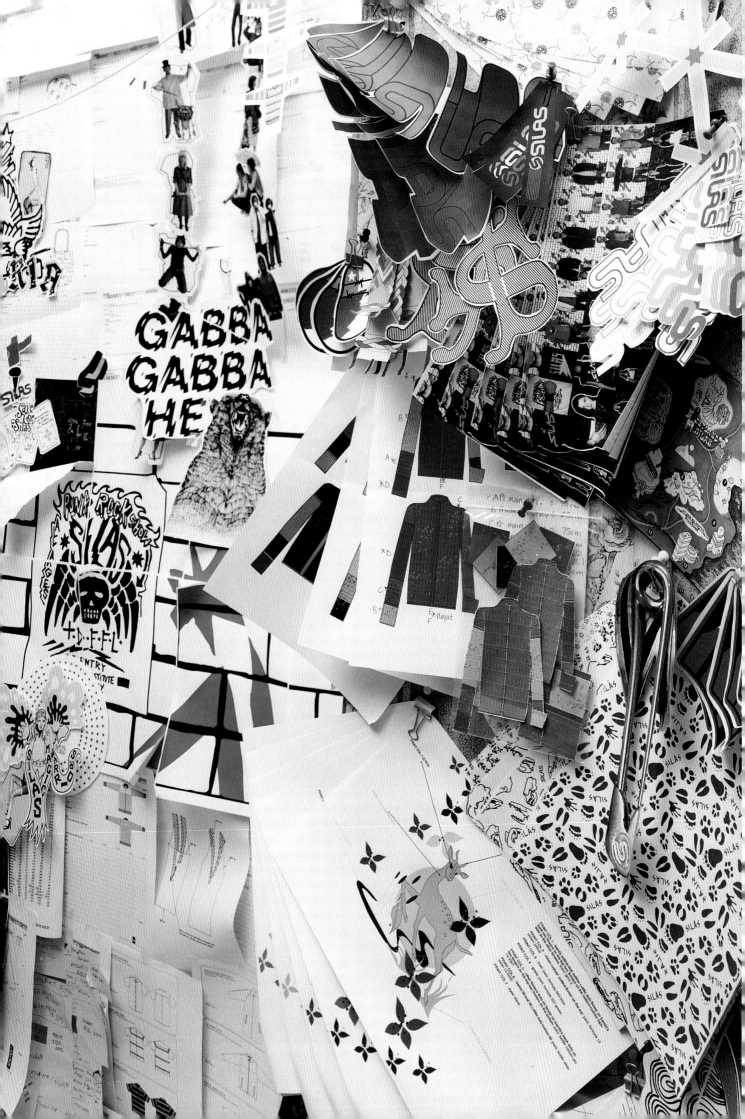

**Down**

2  Overwhelming defeat (4)—
3  Six cricket deliveries (4)
4  Small boat (6)
5  Reflexive word - stifle (anag) (6)
6  Aztec emperor (who takes his reveng
   tourists?) (9)
7  Wipe out (9)
1 1  Tendon behind the knee (9)
1 2  Person who takes risks (4-5)
1 3  Zoom (5)
1 4  Person voting on behalf of anoth
1 8  Football or cricket team (6)
1 9  Of a racial group (6)
2 2  The frigate Lutine's hangs in Lloyd
   London (4)
2 3  Amend a publication (4)

THE WAIST WILL BE BOUND
WITH A PRE FOLDED BIAS.
IT SHOULD BE TOPS...
THRU AT 0·5 cm

# Acute Admissions Department

FORM 1:0
Patient Profile

## 1. Administration details

| | | |
|---|---|---|
| Patient surname | ███████ | |
| Forename(s) | █████ | |
| Date of birth | Unknown   Male  X   Female | |
| Current address | Unknown | |

Postcode

Admission date    21  01  03   Category   Section 23
Supervising psych.   Dr. Elias Rummel
Signature    *E. Rummel*

Additional information (accomp. by police officer, place under suicide watch etc.)

– –

## 2. Preamble

███████ ██████ has been resident in a closed ward at Croxted Hospital since 19 January, when he was sent here for observation and psychiatric evaluation as a result of an order made under Section 23 of the Mental Health Act. The order was made after a series of incidents which included stealing women's lingerie from a washing line, riffling through rubbish bins and persistent harassment in the form of various unwanted attentions. He has also been intercepting couriers to a clothing company called Silas.

If additional space is required please continue on a separate sheet

## 3. Initial observations

███████ ██████ attends his first interview dressed in clothing with lots of deliberate holes. He explains he has had to cut the labels out of all the garments as they were receptor sites for bad messages from Silas Holmes. Silas, he explained, knew that █████ had once worn baby - clothes from a firm called Fruit de Mère, and wanted to punish him. █████ says he loves Silas, but he is also scared of him - hence he cuts out any offending labels. He wants to make Silas happy, and the only way to do that is to honour his name. He says Silas Holmes told him to steal the lingerie etc to test his love. He's scared that Silas is angry with him for being in hospital. He appears anxious. Various motor disturbances: fidgets, grinds teeth. Also sweats a lot. He's able to recite detailed product lists from the Silas company. He thinks that Silas Holmes is its CEO. [NB this is something the company refute.] Silas uses clothing, publicity etc to communicate, and item names - █████ cites the fooling shirts and puffy bras - bear coded messages that it is essential for him to decipher.

If additional space is required please continue on a separate sheet

## 4. Diagnosis / prescription / assesment

█████'s delusions and attendant anxiety levels are consistent with the full-blown manifestation of paranoid dementia, with some florid characteristics of de Clérambault's syndrome. The figure of Silas Holmes (is there any significance in the Holmes/ █████ dyad? note to self; check bookshelves at house), appears as a punitive projection signalling severe disturbance at an early Oedipal level of development. the cutting of labels,clothes etc, is a violent displacement if castration anxiety.

If additional space is required please continue on a separate sheet

| Medication prescribed | Risk assessment |
|---|---|
| Administer largactil suppositories, 3 times a day, see what happens. | With stabilised medication and/or possible lingerie aversion therapy, minimal risk to public. |

Published in 2003 by Laurence King Publishing Ltd
71 Great Russell Street
London WC1B 3BP
United Kingdom
Tel: +44 20 7430 8850
Fax: +44 20 7430 8880
e-mail: enquiries@laurenceking.co.uk
www.laurenceking.co.uk

A catalogue record for this book is available from the British Library

ISBN 1 85669 370 8

Printed in China